BANKSY

LOCATIONS
& TOURS

BY MARTIN BULL

BANKSY LOCATIONS & TOURS
A COLLECTION OF GRAFFITI LOCATIONS AND PHOTOGRAPHS IN LONDON, ENGLAND
The author asserts his moral right to be identified as the author of this work.

UK Edition designed by Stef at hoodacious.co.uk
US Edition designed by Courtney Utt

Published by:
PM Press
PO Box 23912

THE BIG ISSUE FOUNDATION

This book is dedicated to Les, a Big Issue seller I met in Bristol, England.

10% of the author's royalties for this edition will be donated to The Big Issue Foundation (UK registered charity no. 1049077).

100% of sales of a limited edition version of this book is being donated to them.

Over £6,000 has been donated so far from UK sales & a private tour.

FOR MORE INFORMATION, VISIT
WWW.BIGISSUE.CO.UK/FOUNDATION.HTML

INTRODUCTION

Do you fancy wandering the streets of London looking for graffiti, especially by Bristol's finest son, Banksy? Or do you prefer sitting at home in your comfy chair (slippers and pipe optional, but highly recommended in these days of weapons of mass destruction,) looking at photos of his work and reading a bit about them? This unique, 100% unofficial book lets you do either.

Follow my street tours (take an A to Z map as well though!) or take your own DIY tour. Collect all of the locations like a geek (each site is numbered) or just wander around, stopping at the various quirky local attractions, and explore parts of London you may never have visited before. Or just flick through the book while you're on the crapper. It's up to you.

Banksy takes you through three tours of the artist's graffiti in London, telling you where each piece is located, (including postal codes and approximate map/GPS references), what they look like, providing a bit of history, some documentary photographs, accounting for the current status of the graffiti (as of December 2007), as well as local landmarks such as bars, markets and tattoo joints.

Don't expect pseudo-intellectual ramblings on what this graffiti all means, how the Banksy phenomenon has taken off, who he is, who he isn't, why my grandmother looks a bit like Arsenal manager Arsene Wenger, or what the difference is between graffiti and street art. I'm not that interested in intellectualizing all this. I'll let you decide what it all means.

MARTIN BULL

THE GEEKY BIT

Throughout 2006, many people responded to my leading questions (and downright annoyance) about where to find this graffiti. I have also discovered a lot myself while wandering the streets like a stray dog, following hunches and leads, and smelling the odd lamp-post to get that authentic feel.

In an effort to share this info and to let people take their own photos (if they want to – it's not compulsory) I have added the locations of a lot of graffiti (mainly by Banksy and Eine) to two location maps, and in 2006 also arranged and ran a series of free guided tours.

If you want to find all this stuff yourself, there is a free map of Banksy (and other) graffiti, which I have contributed a lot to: www.zeesource.net/maps/map.do?group=1571

There is also an Eine Location Map, which I started and organize. Access is free.

Visit it at www.zeesource.net/maps/map.do?group=6502

I doubt I will do any more tours. There is so little left to show, except on the Farringdon tour. However, I will always try to advertise the tours and any future books or maps on the following sites:

Wallcandy Forum: www.wallcandy.info
The Flickr Banksy group:
 www.flickr.com/groups/banksy/
And my website: www.shellshockphotos.co.uk

HOXTON & SHOREDITCH TOUR

LOCATIONS S1 TO S32

FARRINGDON & CLERKENWELL TOUR

LOCATIONS F1 TO F14

WATERLOO, SOUTH BANK & VICTORIA EMBANKMENT TOUR A.K.A. THE RIVERSIDE RAT TOUR

LOCATIONS R1 TO R19

HOXTON & SHOREDITCH TOUR

THE BIGGEST TOUR BY FAR

At a pretty decent pace, it took us three hours. It could be far longer if you include all the local streets and all the local graffiti. It is everywhere. And it's always changing, so even though a lot of the featured graffiti is gone now, you're bound to always find something new, or have never noticed before.

Literally stumbling across 'the maid' (see S20) early one Sunday morning in May 2006 (I suspect Banksy did it in the first hours of that same morning) was the kind of pleasure you can only really get by wandering around, keeping your eyes open, and following your destiny. You 'll be amazed at how many weird situations have led me to come across this stuff!

This tour goes around the capital of UK street graffiti – Hoxton, Old Street, Shoreditch, and Brick Lane – the creative, yet run-down, nouveau trendy East End. The streets (and railway bridges and alleys) are literally awash with graffiti of all styles, plus paste-ups, stickers, installations, art projects and all sorts of weird and wonderfully creative ramblings (picture frames on the street, nailed up art, tattooists, photographers and fashion victims, etc.)

This tour is the longest of the three, but you could easily split it up, or just wander around a bit instead. You won't need a tube or bus ticket. It's all relatively flat, and doesn't involve any unavoidable steps for someone using a wheelchair or pushing a baby carriage.

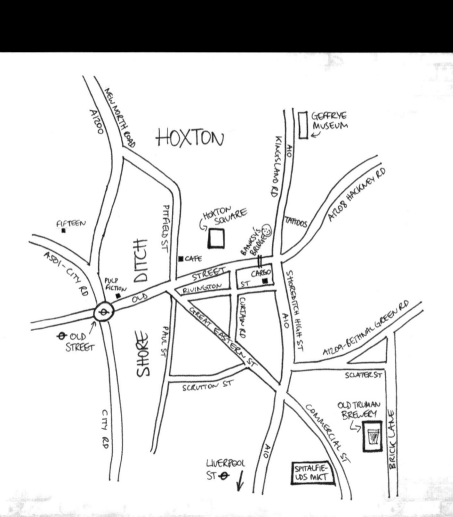

POISON RAT
Post Code: EC1Y 1AU
Map/GPS reference: TQ 32796 82288

Location
Oliver's Yard, just off City Rd (A501). As seen in the Banksy
books. It is now fading, but it is the only Poison Rat left
in the area, complete with green waste spewing across
the pavement, and the word 'Wanksy' added to it!

Status
Hardly visible any more.

Next
Return to Old St station and use the
subways to come out at Exit 8

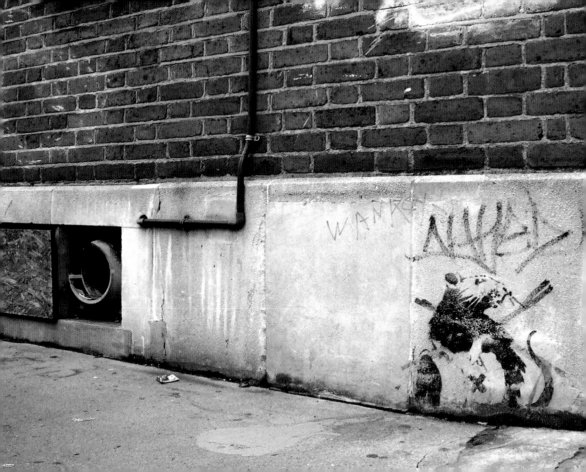

CHECK OUT THE WALL
Post Code: EC1V 2NR
Map/GPS reference: TQ 32706 82522

Location

By Exit 8 of Old Street tube station. It may be white, it may
be black, it may have art on it, it might not. It's an ever-
changing open air gallery. The 'writer' Arofish was the
first to paint this wall white (using the old trick of posing
as a workman) and then came back later to add some art
to it. Since then, it's had a succession of art and paint-
overs, including one cheeky reference by El Chivo to the
re-painting. I wonder what it will look like when you visit?

Next

Walk Up City Rd (A501).

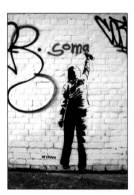

'Soma' by El Chivo, June 2006
followed by 'paint it black...paint it white...'
by El Chivo, Oct 2006 (Both painted over)

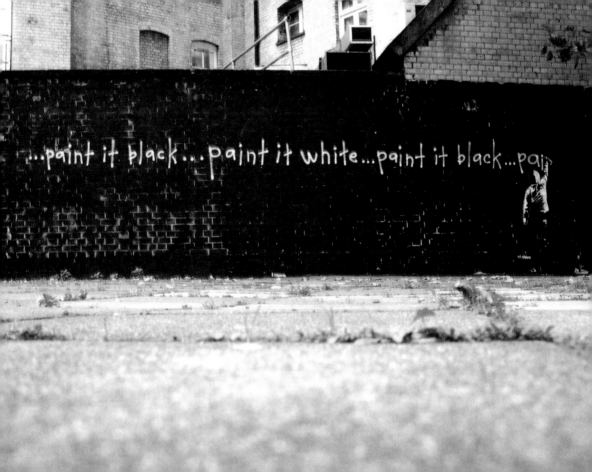

MICROPHONE RAT
Post Code: EC1V 9EH
Map/GPS reference: TQ 32551 82701

Location
Moorfields Eye Hospital, City Road, by Cayton Street.
This is on an old disused entrance to Moorfields, and is a
great example of a large microphone rat, although I like
to think of it as a rat belting out 'My Way' on a karaoke
machine, or maybe toasting at a sweaty sound system
clash in Kingston. For half of 2006, it was covered up
during renovations, but it managed to survive. Workers
told me it wasn't due to be buffed, so I hope it will stay.

Status
In October 2006, the rat was visible again.

Next
Cross City Rd (A501) to Westland Place.

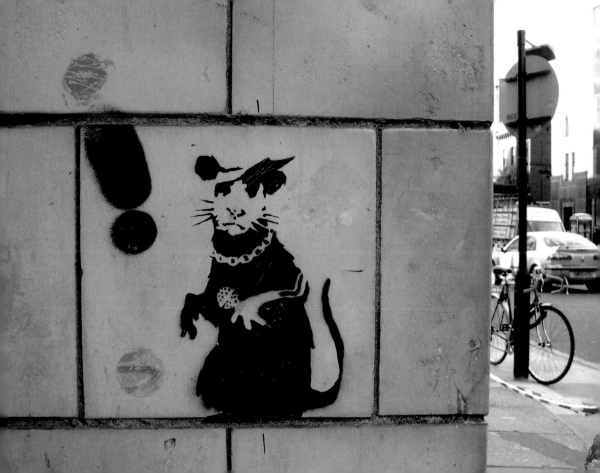

CUTTING RATS
Post Code: N1 7LP
Map/GPS reference: TQ 32551 82807

Location
Outside Fifteen Restaurant, Westland Place. Being an
advocate for tree hugging, pinko liberals, Banksy did
this stencil next to Jamie Oliver's 'social restaurant'
Fifteen in oh-so-trendy Hoxton (he also did the same
stencil on the gates to the Greenpeace office in London)
as if some rats were breaking into it. Is there no end
to this man's humor? There used to be a gangsta
rat just around the corner (see inset photo).

Status
Gone, circa March 2007. The rats were originally on panes
of blackened glass, which have since been removed and
replaced, presumably, by the owners of the building.

Next
Walk up Vestry St, until it joins East Rd.

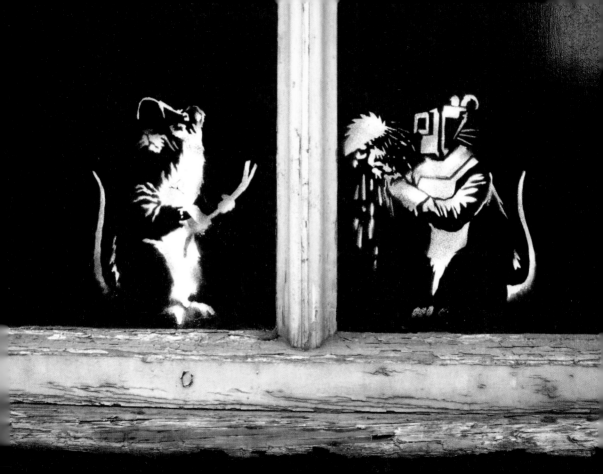

'SMILEY' COPPER
Post Code: N1 7LP
Map/GPS reference: TQ 32551 82807

Location
Slightly tucked away, on the corner of Vestry Street and
East Road, Banksy's 'Smiley' Copper sits on a peeling wall,
after having been amended by an unknown artist to make
it a rather unique 'blank faced' copper instead. Also rather
uniquely, a big Banksy tag covers the stomach area. This
exact graffiti is mentioned in Banksy's book *Wall & Piece*.

Status
Badly Buffed (February 2007). The wall looks a
mess! Shepard Fairey added a paste-up to the wall
during his visit to London in November 2007.

Next
If you fancy a bit of a walk, continue up the New North
Rd to S6 and S7. Otherwise go straight to S8.

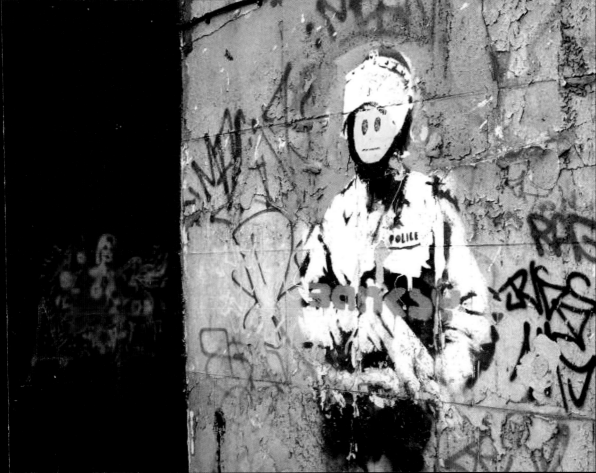

GIRL WITH BALLOON
Post Code: N1 6TA
Map/GPS reference: TQ 32696 83342

Location
On the side of some flats on the New North Road (A1200),
close to Wimbourne Street. During the Spring of 2006,
the balloon was repainted by an unidentified person.

Status
Painted over (March 2007). It can still be vaguely
seen through the new grey paint. I suspected this
might happen as the local housing estate was being
renovated. When that happens, they generally give
everything that doesn't move a coat of paint as well.

Next
Continue up the new North Rd, and down Eagle Wharf Rd.

Erika & Nhatt at
the Girl With Balloon

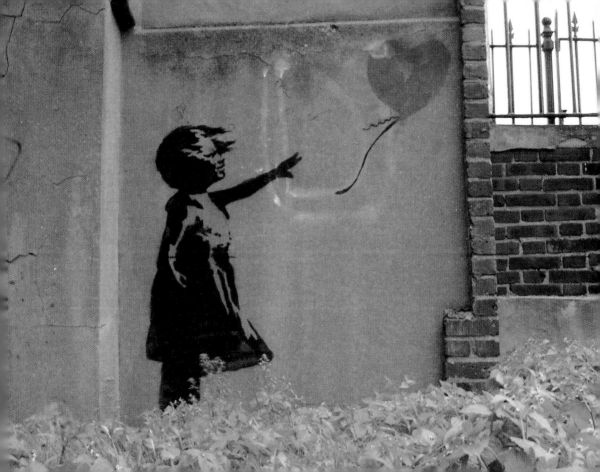

CANAL HOODIE
Post Code: N1 7QR
Map/GPS reference: TQ 32278 83371

Location
Under the footbridge over the Grand Union Canal.
Shepherdess Walk/Eagle Wharf Road. Best viewed from
the bridge or the canal tow path. A good example of how
(I assume) Banksy re-uses stencils, as it seems the same
as the one used for 'Tourist Information' just off Hackney
Road, in Ion Square — now sadly faded into obscurity.

Status
Still there.

Next
Retrace your steps, back towards East Rd.

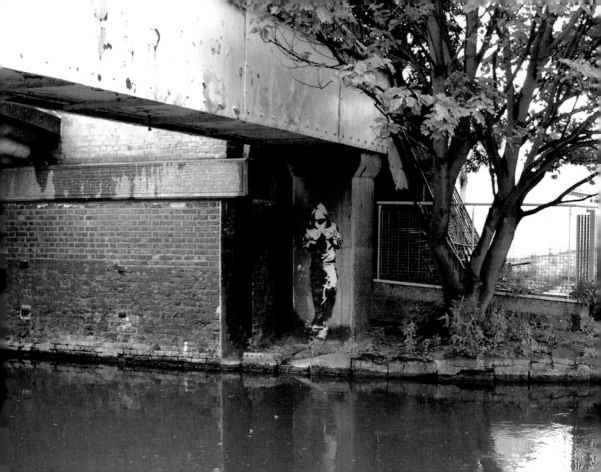

UMBRELLA RAT
Post Code – N1 6JB
Map/GPS reference – TQ 32877 83049

Location
On a lovely house, next to the newsagents on the corner
of East and New North roads. A great little Umbrella Rat
used to live in the corner of a large white section of this
house. I think there was other graffiti there as well, before
the wall was whitewashed, but the Banksy was saved. Six
months later though, the whole wall was painted over.

Status
Painted over.

Next
Continue down New North Rd, to Pitfield St.

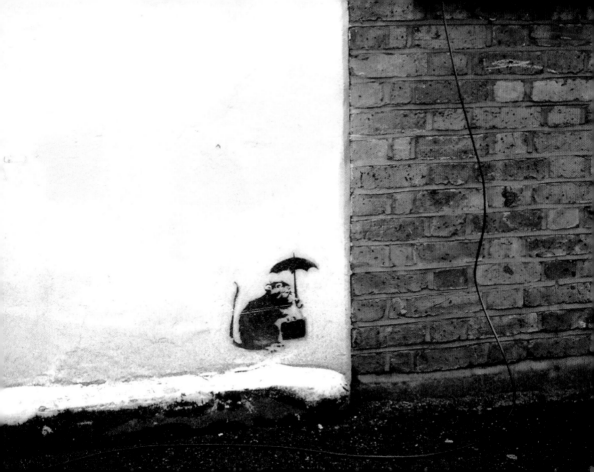

UMBRELLA RAT
Post Code: N1 6BU
Map/GPS reference: TQ 33014 82852

Location
On the metal newsagents box of City Supermarket, 57 Pitfield
Street, near Haberdasher. A pretty awful specimen, with
loads of runs, but it's a good example of how these metal
newsagent boxes are a great target for graffiti writers as
they are left out all night for milk and newspaper deliveries.

Status
Buffed (circa December 2006).

Next
Continue down Pitfield St.

BLT TIP: I don't eat animal products so I can't judge the kebabs for you, but the 'Best Kebab & Café' at the bottom of Pitfield St does a lovely falafel meal, and the coffee and the service are great too.

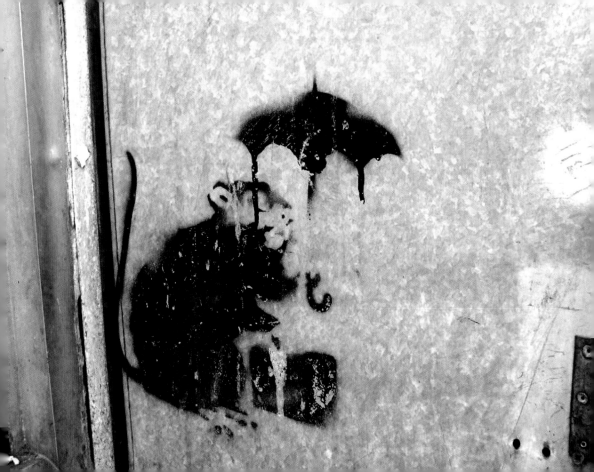

LOOK ACROSS TO HAVE A NICE DAY
Post Code: EC2A 3JD
Map/GPS reference: TQ 32978 82519

Location
Above 'Wa Do Chinese Fast Food' shop on the corner of
Old Street & Tabernacle St. This is now rather ironically
obscured by the massive advertising hoardings above, and
the shop sign below. However, you could climb up on the
roof. There is a great photo of this in the snow in Banksy's
books, when it used to be Franco's Fish & Chips shop.

Status
Still there, but very obscured.

Next
Cross over half of Old Street by the Foundry.

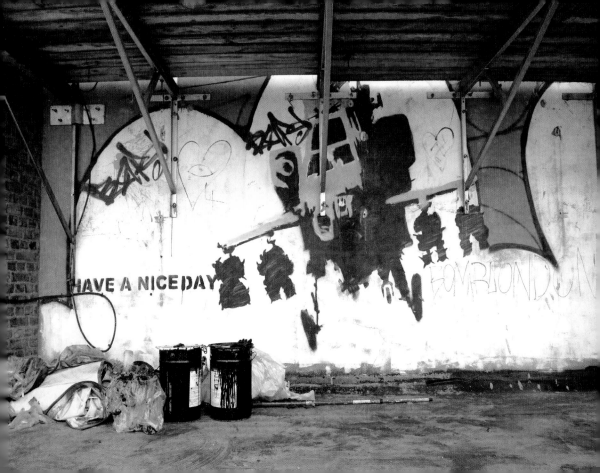

THE FOUNDRY
Post Code: EC2A 3JL
Map/GPS reference: TQ 33057 82557

Location

Inside this eclectic Hoxton bar/venue/exhibition area
(situated where Old St and Great Eastern Street
collide), there is a mess of graffiti on the downstairs
walls, surrounding the toilets (and inside the toilets a
bit. Any writer who has had work displayed in the venue,
or is generally good enough, is 'allowed' to add to the
wall. Banksy has contributed a grin reaper, a happy
chopper, and a tag. Notable others on the wall include
Faile, and Arofish, who had an exhibition there a few
years ago. The Foundry seems to operate whatever
opening hours it feels. Generally, it's a night time place,
of course. www.foundry.tv might help. Or it might not.

Status

Looks great, as long as you don't mind the walls being a
complete and deliberate mess of tags/stencils/paint.

Next

Look down to the Pulp Fiction site (S12), or go up closer to it.

LOOK DOWN TO THE PULP FICTION SITE
Post Code: EC1V 9PB
Map/GPS reference: TQ 32834 82543

Location
Above a row of shops on Old Street, near Vine. One of the most famous sites in London, but also very hard to photograph and view. Staying further away often gives you a better view of it. For several years it had Banksy's famous *Pulp Fiction* piece on it. In May 2006 Shepard Fairey put a massive *Obey* poster up, and Faile flanked it on both sides with their snarling dog wheat pastes. 'Banksy was here' was also crudely added on top in a pink paint that looked suspiciously the same shade that both Faile and Banksy had recently used around town. Then in July, a new version of *Pulp Fiction* went up, followed in September with a complete paste-over, and a crudely drawn message stating 'Nothing Last's Forever.' As they say, great art is all in the composition. Throughout the rest of 2006 and most of 2007 the wall was pretty crappy. Every time I went to the area, I always checked it out, and every time was disappointed.

Fast forward. It's 5:30pm on September 9th, 2007. I'm on the top deck as my bus goes past the site. I half-heartedly turn to look at the wall. OMG! I jump up, ring the buzzer, and stop the bus. I'm excited not just because it's new, but because it has Banksy metaphorically written all over it (although many amazingly doubted it at first!) and most importantly because it was the first piece of graffiti for months to actualyl stop me in my tracks, to move me, to make me fall in love again. The quality is amazing,

and the subject poignant. For me, Banksy was back on top. The quality said 'I'm the daddy' (see the film Scum.)

Interestingly it was spotted that at 3pm that day the site was still shrouded in blue tarpaulin (some of which was left on the roof). This now seems to be a favorite Banksy trick, to actually cover a site in tarpaulin/scaffolding to gain the time and privacy to do a good job.

Soon it was on Banksy's website, with an explanation. It was called 'Old St. Cherub' and was done shortly after several children had been affected by gun crime. Banksy wrote "Last time I hit this spot I painted a crap picture of two men in banana costumes waving handguns. A few weeks later, a writer called Ozone completely dogged it and then wrote 'If it's better next time I'll leave it' in the bottom corner. When we lost Ozone [Ozone – 21-year-old Bradley Chapman – was killed by a train in January 2007] we lost a fearless graffiti writer, and, as it turns out, a pretty perceptive art critic. Ozone – rest in peace."

Status
It's likely to change by the time I've even finished this sentence....

Next
Turn into Rivington St.

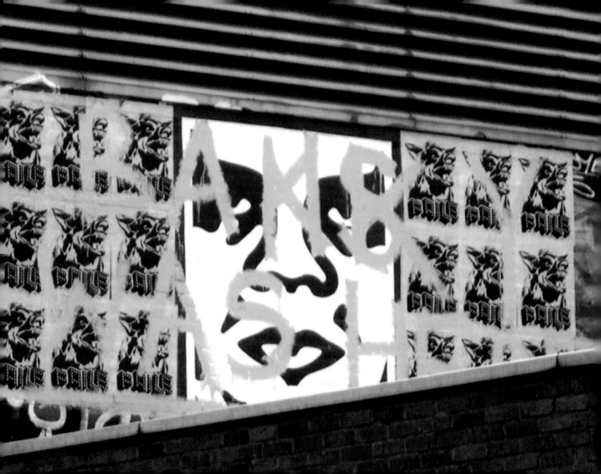

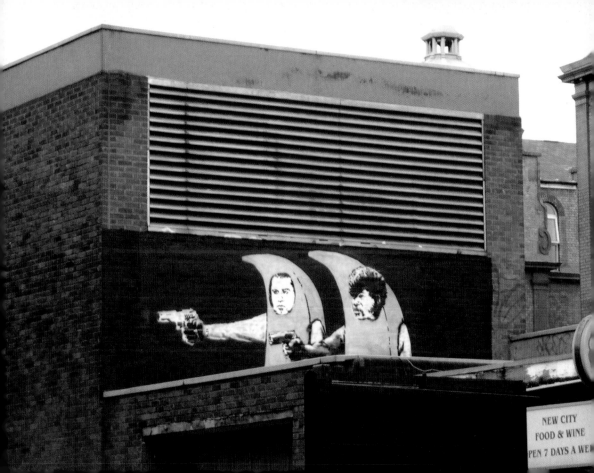

NEW CITY
FOOD & WINE
PEN 7 DAYS A WE

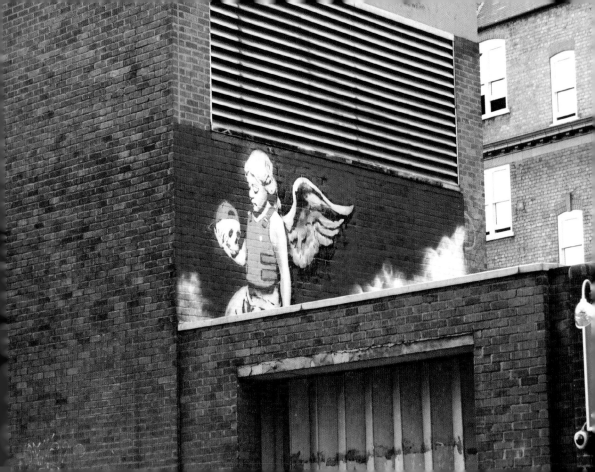

TV OUT OF THE WINDOW & GIANT RAT
Post Code: EC2A 3DT
Map/GPS reference: TQ 33059 82549

Location
In a private car park called Ridgeway Place, on the
corner of Rivington Street and Old/Great Eastern
Streets. Another great site, which includes Banksy's
TV Out of the Window, and an enormous rat with a knife
and a fork similar in size and shape to the rat Banksy
created in Liverpool for the 2004 Art Biennial. The
private car park seems to keep irregular opening hours,
but it's best to see the art when the gates are open.

Status
The graffiti is getting closer. December 2007,
wooden hoardings covered them up, apparently in
preparations for the graffiti to be removed and sold.

Next
Cross Great Eastern St.

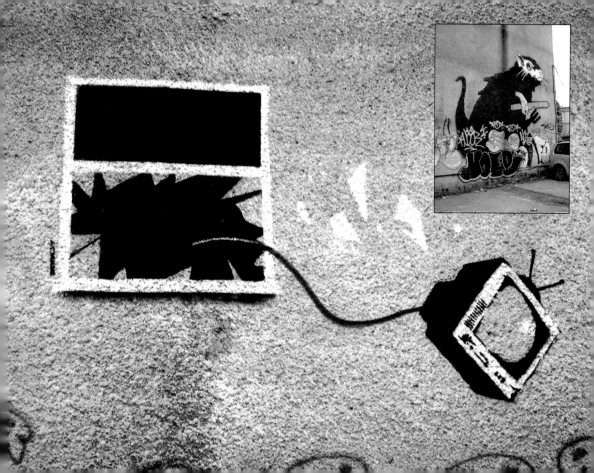

GRIN REAPER
Post Code: EC2A 4NY
Map/GPS reference: TQ 33003 82467

Location
On the side of a bar called 'Yard' on the corner of Paul and
Tabernacle streets, there's a very faded Grin Reaper. It's
hardly worth mentioning, but a good example of something
that fades away, or is buffed to within an inch of its life.

Status
Very faded.

Next
Continue down Paul Street, past the large metal sculpture
on Leonard St that used to be a favorite spot for graffiti
artists, stickerists and bill posters, until it was completely
stripped, cleaned and painted in some anti-graffiti coating
in Sept 2006. In October, Blek Le Rat was the first to get
anything to stick on it, but it only lasted a few days...

GRIN REAPER
Post Code: EC2A 4RT
Map/GPS reference: TQ 33030 82209

Location
On Scrutton, near Clifton Street. A stunning
yellow Grin Reaper on a blue wall where the
old *Pictures On Walls* office used to be.

Status
Still very impressive, but it is slowly getting dogged.

Next
Continue down Scrutton St.

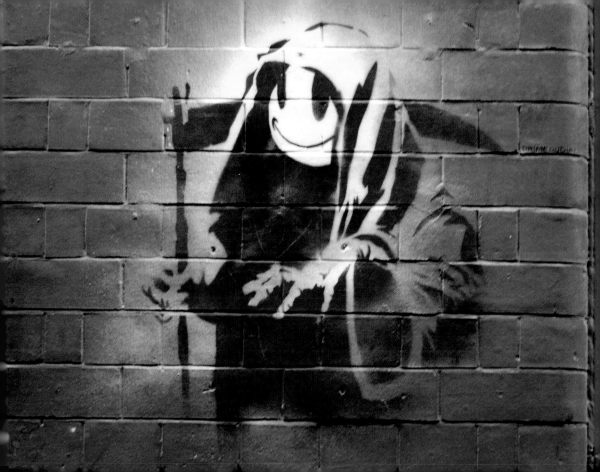

HAPPY CHOPPERS
Post Code: EC2A 4XB
Map/GPS reference: TQ 33113 82180

Location
On Holywell Row, tucked away behind a blind corner.
There are usually some Faile paste-ups on the
building opposite. See the inset photo. This is an
unofficial Faile history site that they post on every
time they come to London.

Status
Mainly painted over. The top of one helicopter was
still visible for a while but, when I visited again in
September 2007, the whole alley was completely
blocked off. The Faile paste-ups have gone.

Next
Go back to Scrutton Street, and continue along.

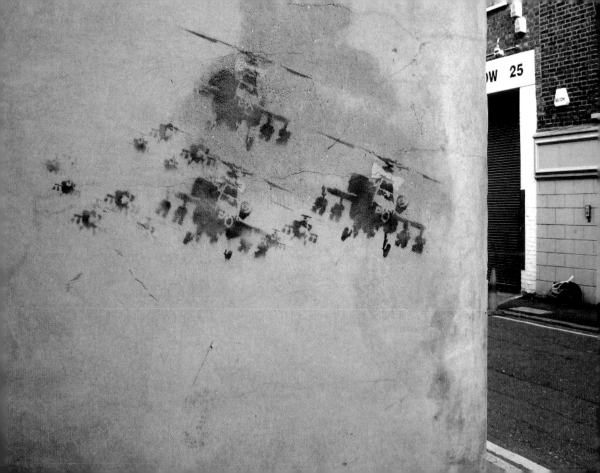

RED CARPET RATS
Post Code: EC2A 3PT
Map/GPS reference: TQ 33259 82286

Location
On the corner of Curtain Road & Christina Street, by
Pizza Express. I first photographed this in January 2006.
By the time I went back a week or so later, it had pretty
much gone. (I often revisit sites. I had also stupidly
lost all my digital photos from the January visit!)

Status
The rats are barely noticeable, but the red 'carpet' is
still quite visible on the pavement. See inset photo.

Next
Head up Curtain Rd.

BLT TIP

Watch out in this area for the newer 'neon style' Eine alphabet letters (C & F – although one was then buffed). A large Space Invader also used to exist in the distance, on the old rail bridge, until it was demolished during the summer of 2007. It's always worth wandering around the New Yard Inn area, and checking out the blind spots around the side and back of The Old Blue Last pub, as they are often covered with art.

Over the years, a Girl With Balloon and a soldier painting an anarchy sign have been there, but they disappeared quite a while ago. The photo shows us in the New Yard Inn area, while on a tour of Shoreditch.

DESIGNATED PICNIC AREAS
Post Code: EC2A 3AH
Map/GPS reference: TQ 33294 82478

Location
On the small steps of a derelict building on Curtain Rd (near
Curtain Place), and on the Curtain Road end of a skanky alley,
Dereham Place, are two faded but enigmatic 'Designated
Picnic Areas.' The one on the steps is one of my favorites
anywhere. The entrance it's on is usually plastered with old
posters and litter, and has looked liked that for ages.

Status
(1) faded, but visible (2) Buffed circa December 2006.

Next
Cross the road towards 'The Elbow Room'...

SNORTING COPPER & WHITE LINE
Post Code: EC2A 3BS
Map/GPS reference: TQ 33249 82500

Location
The Snorting Copper was just off Curtain Road (by 'The Elbow Room' Pool Lounge & Bar). The white line goes along the alley (Mills Court) and into a drain on Charlotte Rd. One day in May 2006, the Council came along and badly jet-washed it (see inset photo). Ironically, it then looked far worse! At least this art was making an attempt to brighten up the streets and get our brains thinking. A version still exists at Waterloo Station (see R6).

Status
Buffed in May 2006, but with a touch of mimicry of the Waterloo one, there is now a Space Invader above it.

Next
Walk up Charlotte Road.

BLT TIP: This alley (Mills Court) often has good graffiti in it. A good El Chivo may still be there when you visit.

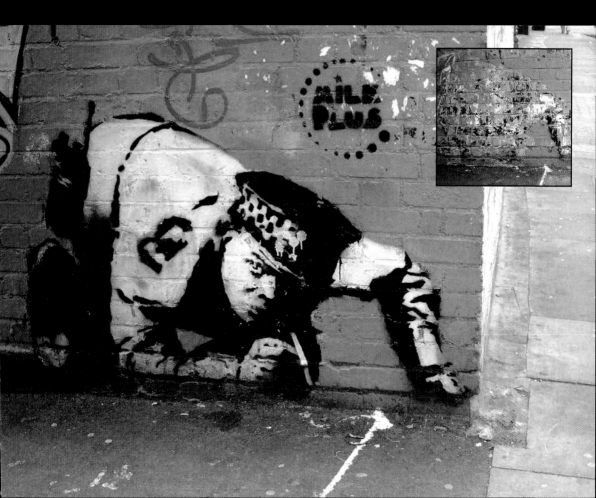

THE MAID
Post Code: EC2A 3PT
Map/GPS reference: TQ 33259 82286

Location

On the side of Jay Joplin's White Cube gallery (Rufus Street
side) in Hoxton Square for about 6 weeks in mid-2006, before
they probably decided it was too much competition for their
own exhibits, and painted over it. Literally being the first
to 'discover' this by stumbling across it early one Sunday
morning in May 2006 (I suspect Banksy did it in the early
hours of that same morning) was a real pleasure – the kind
you can only experience by wandering around and accidentally
discovering something. One annoyingly sentimental and
highbrow comment about this book was that it made it too
easy to find graffiti and therefore made it a common and
accessible experience. Apparently finding things by wandering
is called *serendipity*. I had to look that up in the dictionary. ☺

Status

Painted over, but still vaguely traceable if you look hard.

Next

Walk along Hoxton Square, back to Old St.

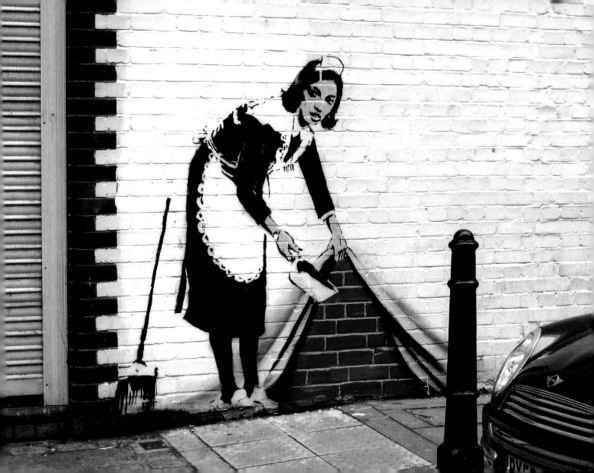

ABANDON HOPE, OLD ST BRIDGE
Post Code: EC1V 9LP
Map/GPS reference: TQ 33371 82674

Location
Another Banksy icon. A train bridge across Old St,
near Shoreditch High Street. And one of the few
times Banksy used pasted-up posters. Over several
years, Banksy regularly added images and messages
to this bridge. The final message was 'Abandon Hope'
in Spring 2006. It only lasted a week or so.

Status
Bits of the Smiley Soldiers were still visible for a
while, until the bridge was completely stripped and
repainted in Sept 2006 in preparation for the extension
to the East London tube line. But I bet Banksy won't
be able to resist targeting it again one day!

Next
Turn up Kingsland Road and walk up to Cremer St.

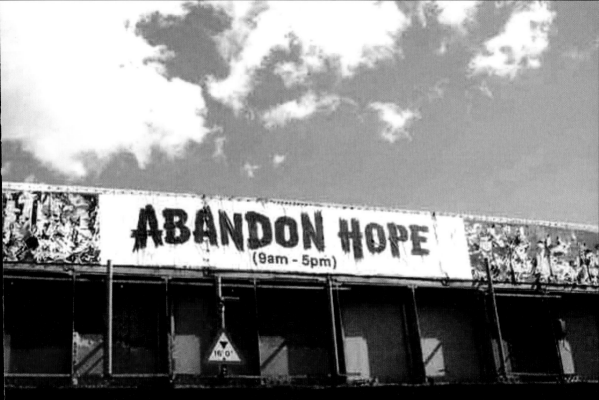

CUTTING RAT
Post Code: E2 8EA
Map/GPS reference: TQ 33573 83118

Location
On metal doors to one of the 'underneath the arches'
workshops on Geffrye Street. Only one cutting
rat this time. Because it cuts into the padlock, the
image has a marvelous contextual power.

Status
Gone. The half of the metal door with the Banksy on
it was taken in late February 2007. Wooden boards
replaced it. Yet another that seems to be have been
stolen! All the workshops are boarded up in preparation
for the extension to the East London tube line.

Next
Walk along Cremer St, & cross the Hackney Road.

PARACHUTE RAT
Post Code: E2 7RA
Map/GPS reference: TQ 33712 82975

Location
Diss Street. This was the best, and most
photogenic parachute rat around until it fell
afoul of the Council clean up campaign.

Status
Buffed (circa December 2006).

Next
Return to Hackney Rd, and turn right,
heading away from Shoreditch.

ALTERNATIVELY: Avoid S23 by returning to the Hackney Road,
and head down it, back towards Shoreditch. Several Eine'd
shop shutters (and Eine and Cept's illusion piece) exist on
Hackney Rd. The Gorsuch Place area is often awash with art.

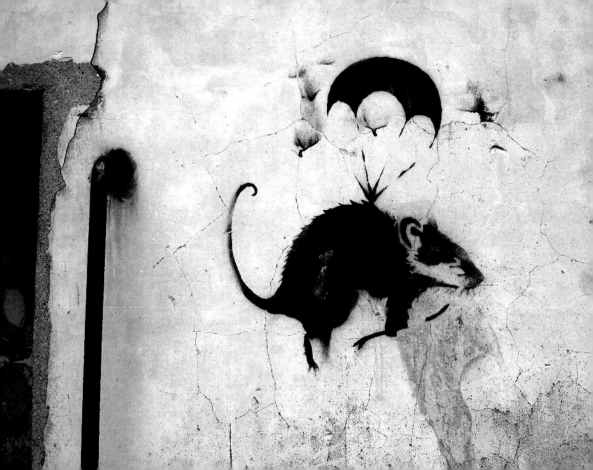

KEEP IT REAL
Post Code: E2 7QB
Map/GPS reference: TQ 33927 82885

Location
Towards the bottom of Ravenscroft Street, close to
Columbia Road.

There is only one rule in life. Just one. You can never have
enough monkeys. That's it. Sorry if I have now spoiled the
meaning of life for you, but you had to know sooner or later.
Oh, and while I'm making peoples lives better, I'll let you in
on a secret. The tooth fairies don't really leave you money in
return for your teeth, it's your parents. Never the greatest
graffiti (it was very small, hence the detail was poor,) but for
a long time it was the only surviving example around.

Status
Buffed (circa December 2006.)

Next
Walk down Columbia Road, onto Hackney
Rd, to Shoreditch High St.

BLT TIP: Check out the Happy
Sailor Tattoo shop at the bottom of
Hackney Rd (near Austin St.) which
used to have several personalized
Banksy prints on their walls. And if you
want some tattoos done also check
out the Shangri-La tattoo parlour at
52 Kingsland Rd (by the rail bridge).

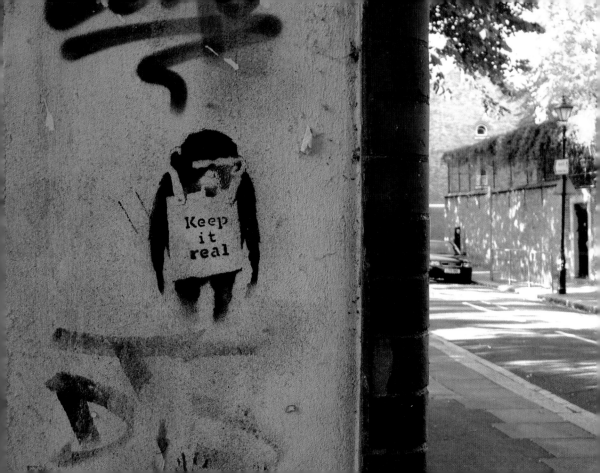

THE 'CARGO' AREA

BOY & PAINT BRUSH
Post Code: EC2A 3AY
Map/GPS reference: TQ 33379 82551

CARGO
Post Code: EC2A 3AZ
Map/GPS reference: TQ 33374 82586

DESIGNATED PICNIC AREA
Post Code: EC2A 3BE
Map/GPS reference: TQ 33363 82594

Location
Rivington St, near Shoreditch High Street (A10.)

Status
1 = Buffed.
2 & 3 = Still fine, although in March 2007 both Banksys in
the Cargo courtyard were covered with perspex, reminiscent
of the sanitized 'street art' at the Old Truman Brewery.

Next
Return to Shoreditch High St, and head south.
(towards Brick Lane/Liverpool St).

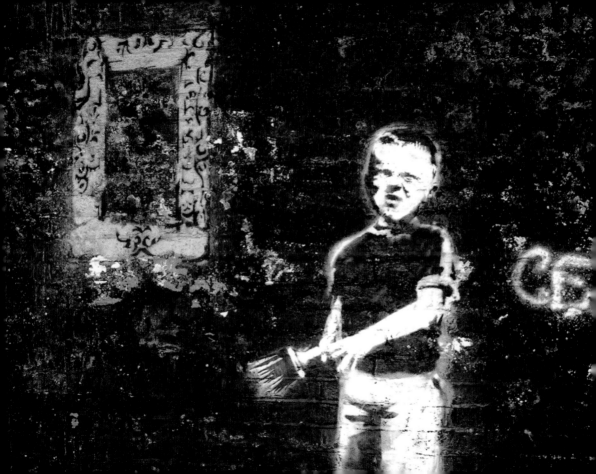

CARGO IS OFTEN REFERRED TO AS A SUPER CLUB AS IT'S SO DAMN COOL.

It has pretty much supported Banksy from the start. Two of his works remain in the back courtyard, which seems to suggest great respect for the aritst as many of the other walls in the courtyard routinely host newer works of art.

The Guard and Poodle (and designated graffiti area) dominate the first wall. The courtyard is often open – for free – when the club isn't charging for entrance to the main club, although since they added wooden decking and loads of greenery in mid-2006, it is harder to see and photograph.

A few walls away (past some great Shepard Fairey paste-ups, see inset photo on previous page) Banksy's HMV image remains, surrounded by other graffiti from Stylo of the VOP crew – check out www.vopstars.com

Just outside the club, a slightly forlorn 'kid with paint brush' lurked under the railway bridge until badly buffed in November 2006. Of the four times this image was used in London, this one seems to be the least finished, or in a well chosen environment. I wonder if it was a job half finished..?

Finally there is a 'Designated Picnic Area' and arrow in an alley (Standard Place) just a short distance from Cargo. The black & silver bubble graf around it actually enhances it in my opinion.

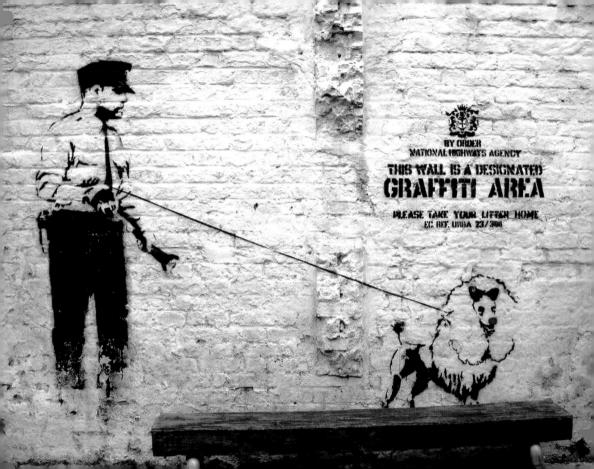

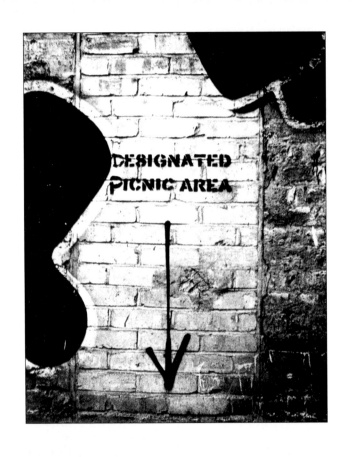

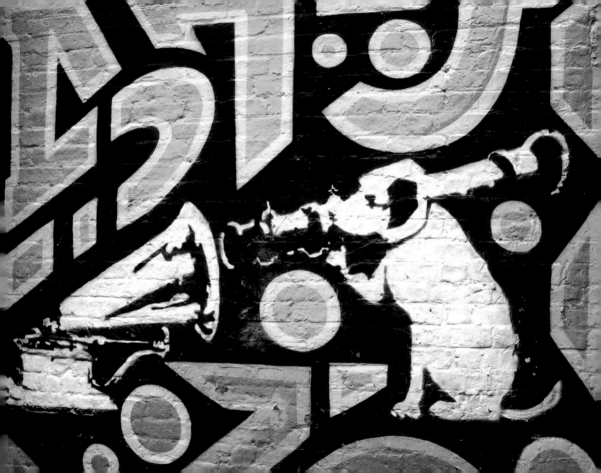

BANKSY TAG
Post Code: E2 7HX
Map/GPS reference: TQ 33741 82409

Location
On the Turville Street side of Anisha Cash & Carry, Redchurch
Street. Only the Banksy tag survives (inside the utilities box),
but above it, a sawing rat used to exist. See the Banksy books
(i.e. *Existencilism*) to get a sense of what it looked like before.

Status
The tag is still there.

Next
Walk slightly back, then down Club Row and
across the Bethnal Green Rd (A1209).

PARACHUTE RAT
Post Code: E1 6HT
Map/GPS reference: TQ 33733 82291

Location
On the side of an old building on Sclater Street, near
Bethnal Green Road (A1209), a faded Parachute Rat
just survives, sometimes hidden by the overgrowth.
Note a great illusion style 'Cept' on the shutters to the
old building. There is also an ever-changing gallery
of street art along the walls of Sclater St, usually
including more from Cept (see inset photo) & Dscreet.

Status
Still there.

Next
Continue along Sclater Street. Turn right on to
Brick Lane. Then take a left at Grimsby St.

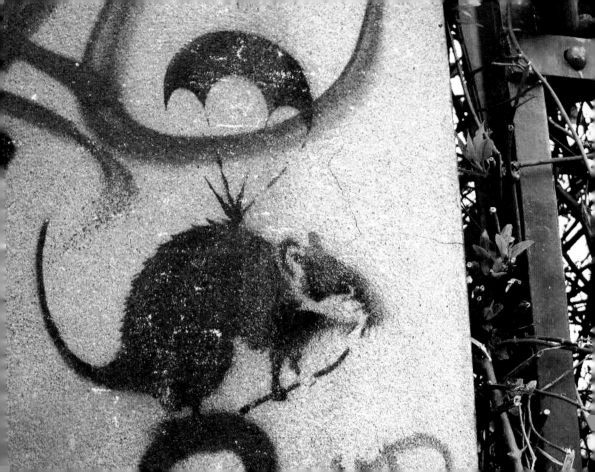

PARACHUTE RAT & BANKSY TAG
Post Code: E2 6ES
Map/GPS reference: TQ 33930 82233

Location
A good Parachute Rat used to exist amidst the gallery of
street art and market shops along Grimsby Street. Tentacles
were later added to it by a person unknown, and over time,
almost disappeared (see inset photo). Don't be fooled by
the small Banksy tag on the wall further down the street.
The large alien/baby figures that used to exist nearby were
not by Banksy. They were by Mr. Yu, a Japanese artist. The
tag relates to a Banksy piece that used to be there; I still
have never managed to find out exactly what was there!

Status
That whole side of the street was boarded up in
2007, presumably for work on the extension to the
East London tube line. The remains of the rat and the
tag may still exist underneath, but it's unlikely.

Next
Return to Brick Lane, towards the old Truman Brewery.

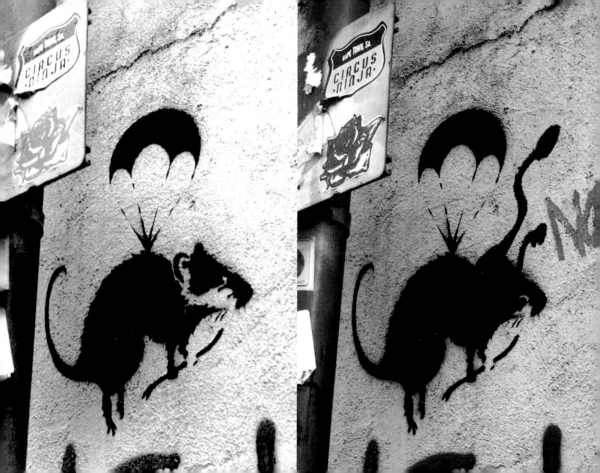

TO ADVERTISE HERE CALL 0800 BANKSY
Post Code: E2 6ES
Map/GPS reference: TQ 33911 82220

Location
Brick Lane, by the old Shoreditch tube station (now
closed.) This exact graffiti is shown in the *Wall & Piece*
book. Seeing this in the flesh is a great sight (with
Eine's version opposite – bloody graffiti writers!).
Beware of the achingly stupid-looking Shoreditch
fashion victims and the Sunday street sellers.

Status
The area is affected by an extension made to the East London
tube line. In March 2007, a temporary bridge was placed over
both of the hoardings (i.e. Banksy & Eine) and the two wooden
boards that contained 'ban' and 'ksy' went missing. Most
of the rest of the Banksy piece followed soon afterwards!

Next
Continue down Brick Lane.

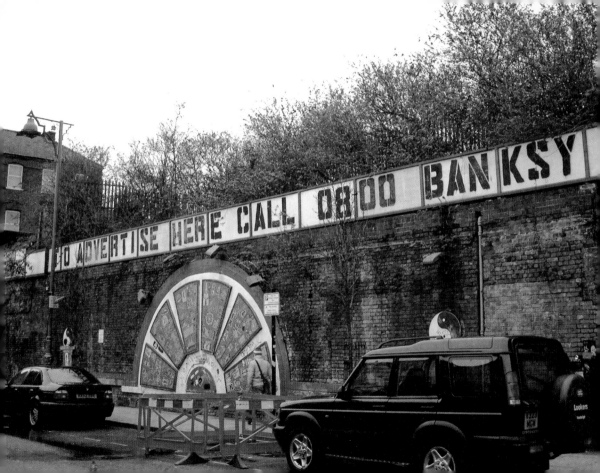

CCTV POLE
Post Code: E1 5HD
Map/GPS reference: TQ 33893 82003

Location
Brick Lane, opposite the side entrance to the old Truman
Brewery. Banksy hit several lampposts and CCTV poles
around London, putting up plastic crows with pirate
flags and cigarettes, pulling at the electrical wiring.
A Banksy tag exists on this pole, so I assume this
was one of those sites at some point in the past?

Status
Tag still there.

Next
Continue just a few meters down Brick Lane,
to the corner with Woodseer St.

GAS MASK GIRL
Post Code: E1 5HD
Map/GPS reference: TQ 33895 81983

Location
Brick Lane, on the corner with Woodseer. Very faded,
but it's the only example I know of in London.

Status
Rather faded, and often attacked by
the remnants of fly posters.

Next
Head back up Brick Lane a few meters, and
go into the old Truman Brewery area.

Rich Mix

3 screen cinema + cafe
Booking Line 020 7613 7498

PINK CAR
Post Code: E1 5HD
Map/GPS reference: TQ 33893 82003

Location
On top of an old shipping container, in the main concourse
area of the old Truman Brewery area. I've never quite found
out the reason for this, but an old Triumph Spitfire GT6 has
been given the Banksy treatment. A good photographic history
of the site exists on the Banksy group on Flickr. A Banksy tag
exists on the far right of the container. Many photographers
make sure they get 'the Gherkin' in the background to
their photo of this. I prefer to get the skanky, derelict old
graffiti/drugs/alcoholic/hooker den in the background (it's
on Grey Eagle Street, but last time I looked it had been
locked up!) Pieces by Space Invader, Dscreet, Obey, D*face
and Faile can often also be seen in this whole area.

Status
Still there. But in November 2006, it was covered
with a horrible see-through box! At least Banksy's
car (see inset photo) now gives it some company.

Next
Carry on wandering around the area if you want (there
is so much to see!). Or if you need a tube station,
continue down Brick Lane to Aldgate East tube station,
or through the side streets to Liverpool St station.

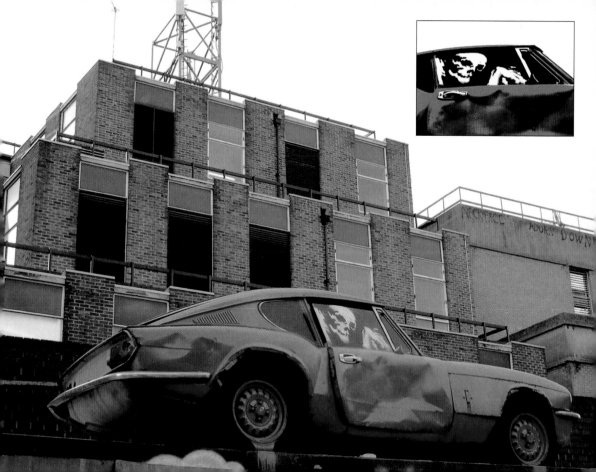

FARRINGDON & CLERKENWELL TOUR

INTRODUCTION

This tour goes around the Barbican/Smithfields area, then heads up to Clerkenwell, Hatton Garden, and finally Farringdon Road and Exmouth Market, ending up by the enormous Mount Pleasant sorting office.

Assuming they are still there by the time the reader may visit, this tour includes loads of excellent quality rats (especially in the Barbican area that I call 'rat city'), the Cash Machine & Girl, and Thugs for Life (or 'old skool' as some know it now). Plus two enormous pieces by Blek Le Rat'. This is the only one of the three tours in the book where, at the time of this book's writing, most of the featured graffiti still exists.

This mini-tour is not very long, and as it's all relatively flat and doesn't involve any unavoidable steps, it is accessible to wheelchairs and baby carriages. When I did it as a tour, it took us just over 1½ hours.

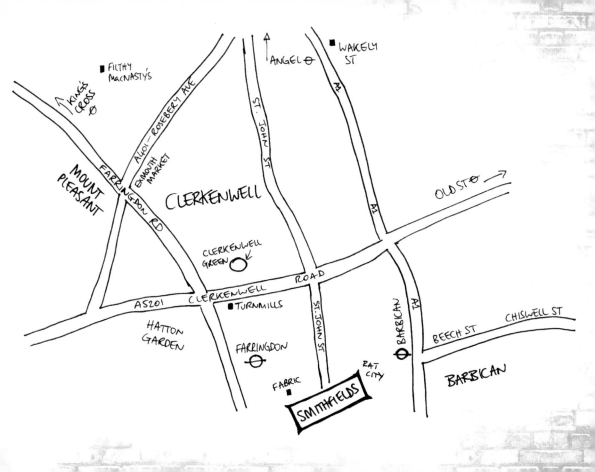

START

The closest tube stations from the first location are Moorgate (Northern, Circle, Metropolitan, and The Hammersmith & City tube lines, plus selected rail services), Barbican (Circle, Metropolitan, and Hammersmith & City), and Liverpool St (Central, Circle, Metropolitan, and Hammersmith & City lines, plus many National rail services).

It's also not that far from Old Street station. If you don't have a map, the best place to start might be Barbican tube station, although it will (rather annoyingly) involve returning to the station after the first location. When you come out of Barbican tube, follow the yellow signs and yellow line that are on the pavement (marked 'Barbican Centre'). This will take you through the covered underpass (Beech St).

As you come out of the underpass, carry on (slight kink in the road to the right) for about another 100 meters and the Banksy placard rat ('London Doesn't Work') is straight in front of you, on a white wall outside 39/40 Chiswell St, just before the St Paul's Tavern, which is on the other side of the road.

PLACARD RAT 'LONDON DOESN'T WORK'
Post Code: EC1Y 4SB
Map/GPS reference: TQ 32497 81970

Location
Chiswell St, near Lamb's Passage.

This is a brilliant example of Banksy's placard rat, this time
announcing that 'London Doesn't Work'. This is one of the
most popular black & white photos that I sell. In a stroke
of genius, I took my photo of it with a London taxi going
past (surely one of the iconic images of London – not that
I'm saying taxi drivers are what makes London not work.)
Unfortunately it was a silver taxi and not the black version!
Tough. Take your own photo if you prefer, smart ass. ☺

Status
Still there.

Next
Walk towards Barbican tube, through the Beech
St underpass. Cross Aldersgate by Barbican
tube station, and continue into Long Lane.

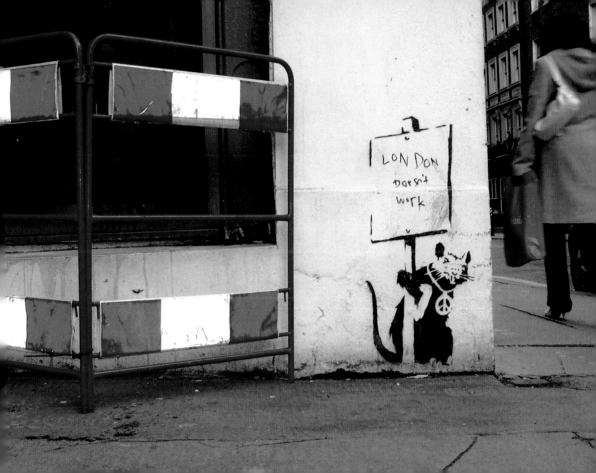

FADED PLACARD RAT
Post Code: EC1A 9HF
Map/GPS reference: TQ 32065 81844

Location
On Long Lane, just around the corner from Barbican tube station. A very faded Placard Rat. Hardly worth mentioning, but a good example of how this one (on the main road) has been buffed to within an inch of its life, whereas the gaggle of rats (or litter, or gang, or parliament, or whatever it is) around the corner are treated as preserved works of art!

Status
Hard to see, even if you know where it is!

Next
Continue along Long Lane a short distance, and into Hayne St.

THE RAT PACK
Post Code: EC1A 9HG
Map/GPS reference: TQ 31941 81847

Location

All within twenty meters of each other, on Hayne Street
and Charterhouse Square. Banksy obviously had a bit of
a mentalist moment in the Barbican area one night. Within
20 meters, there are four different stencils adorning the
walls. B, C & D (see below) are all on the same building.
When it got repainted, they actually painted around
the Banksy pieces, thus preserving them! Respect.

Status

All are still there, but three have been painted
around, which sort of spoils it a bit. Could
be worse though, they could be gone!

Next

Take the detour to F7, or continue along
Charterhouse Square/Street towards F4.

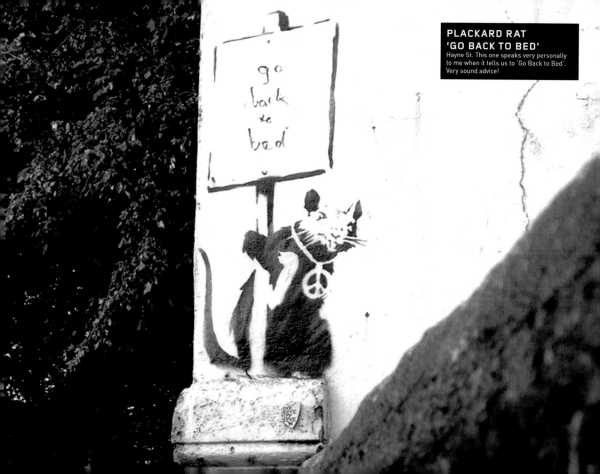

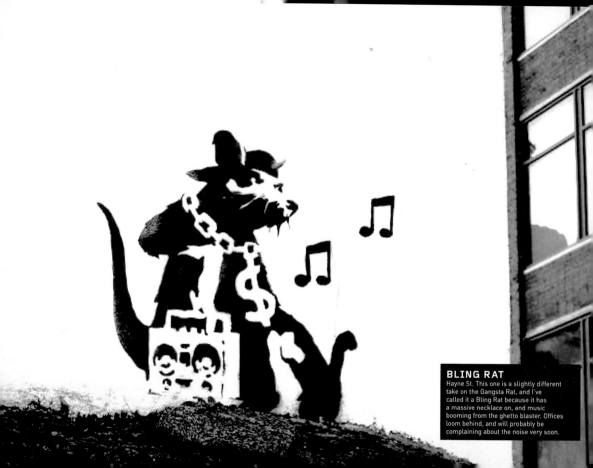

BLING RAT
Hayne St. This one is a slightly different take on the Gangsta Rat, and I've called it a Bling Rat because it has a massive necklace on, and music booming from the ghetto blaster. Offices loom behind, and will probably be complaining about the noise very soon.

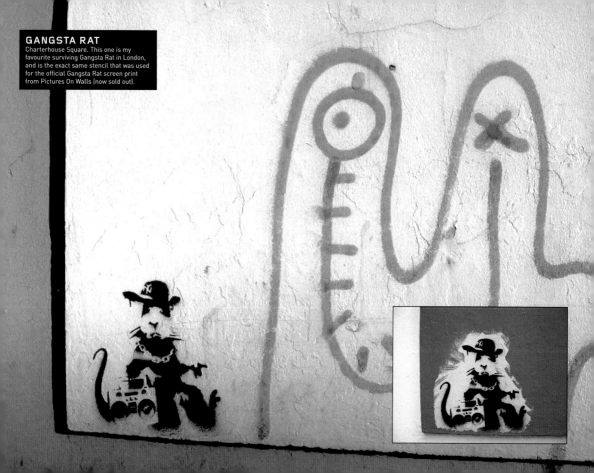

GANGSTA RAT

Charterhouse Square. This one is my favourite surviving Gangsta Rat in London, and is the exact same stencil that was used for the official Gangsta Rat screen print from Pictures On Walls (now sold out).

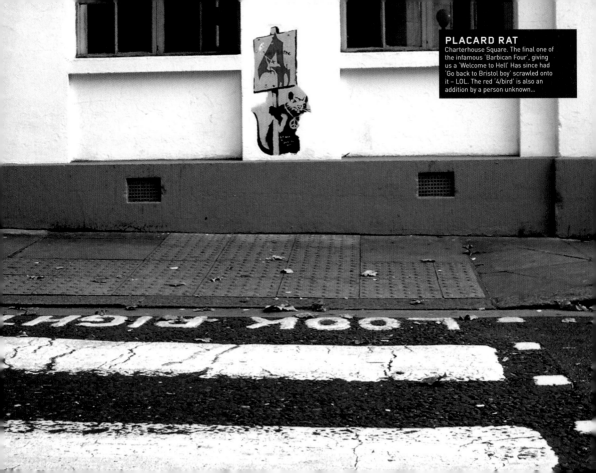

GO BACK TO BRISTOL BOY

BLT TIP: To see some other street art in the area follow F4 & F5. If you couldn't give a toss, go straight to F7 for another Banksy.

FAILE STENCILS
Post Code: EC1A 9HL
Map/GPS reference: TQ 31943 81802

Location
On Lindsey St, opposite the East side of Smithfields market.
I spotted these early in June 2006, but they might have
also been part of the Faile blitz in late May 2006 when the
Faile people plastered Shoreditch with various examples of
their name, and snarling dog wheatpastes. Two fantastically
detailed stencils ('Smoking' & 'Monster') are on the wall
of an old 'Men's Lavatory' next to Smithfields market.

Status
A very bad attempt was made to buff it
in early 2007 (see inset photo).

Next
Join Long Lane again and continue along,
as it becomes West Smithfield.

D*FACE – SKELETON QUEEN
Post Code: EC1A 9LY
Map/GPS reference: TQ 31594 81597

Location
On West Smithfield, close to Farringdon St (A201). D*face is another great street and gallery artist. He celebrated the Queen's 80th birthday in 2006 by releasing a print and putting up these pastes in a few places in London, showing the Queen just in her bones. It's called 'Canis Servo Regina' which knowing D's obsessions probably means something like his previous print, 'Dog Save the Queen'. I deliberately left the surroundings in the photo, as that is partly what drew me to photograph the paste up in the first place. Smithfield's is a rather run down part of our heritage. A bit like the Queen, really.

Status
Pasted over with fly posters circa December 2006.

Next
Walk through/under the market, out onto Charterhouse Street.

BOMB HUGGER
Post Code: EC1M 3HN
Map/GPS reference: TQ 31709 81783

Location
Inside 'Fabric' club, 77a Charterhouse St. For all you
drum 'n' bass heads out there, a night out at Fabric will
not only make your jinglies jangle, but you can also check
out a Banksy Bomb Hugger sprayed straight onto the
wall, by the toilets. They even put a frame around it.

Status
Still there.

Next
Continue along Charterhouse St., to St. John's Street.

BLT TIP

On your way up St. John's Street (between F7 & F8) you used to be able to check out a large road sign that had large Obey & D*face paste-ups on it (see inset photo). However, the whole sign was removed in early 2007.

You can still check out two from Blek Le Rat, inside shops on the right hand side of St. John's Street, approx opposite Aylesbury St.

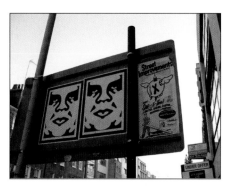

GANGSTA RAT
Post Code: EC1M 4BL
Map/GPS reference: TQ 31772 81903

Location
Floor level, near some railings on Peter's Lane (just off
St. John's Street). Yeah, yet another rat, but another good
quality one and a very ironic addition. Someone has written
'not a banksy' on it, when in fact it looks like one of the
clearest Banksys I've ever seen. Sure, they can be faked (and
there are some questionable ones out there), but I doubt
this one is. The buildings on the opposite side of St. John's
Street were used as the 'Trans- Siberian Restaurant' in
David Cronenberg's excellent 2007 film Eastern Promises.
One of Eine's shop shutters in Broadway Market (Hackney)
was also featured in the opening scenes of the film.

Status
Still there, but repetitive images of a woman's face
were added to the right of it in early 2007, and later
in the year various other daubs were added, including
the comment 'Shit off I'm proper Banksy'!

Next
Continue up St. John's Street.

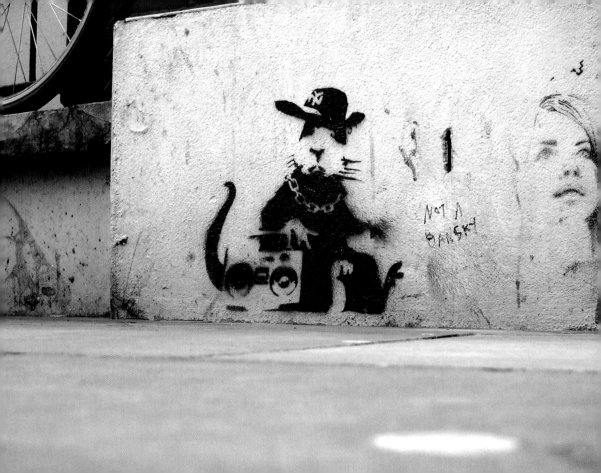

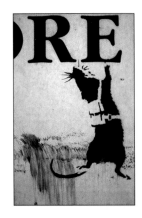

REFUSE STORE HANGING RAT

Post Code: EC1V 4JY
Map/GPS reference: TQ 31688 82363

Location

Bottom end of Agdon St. (just off St. John's Street/Compton Street). I love the placement of this little rat, hanging off a door marked 'Refuse Store.' The metal door gives a photo a grey tone, but if you play around with the image, you can also get it into a nicely contrasting black & white image.

Status

Still there.

Next

Return a short distance down St. John's Street, and walk along Aylesbury St. towards Clerkenwell Green.

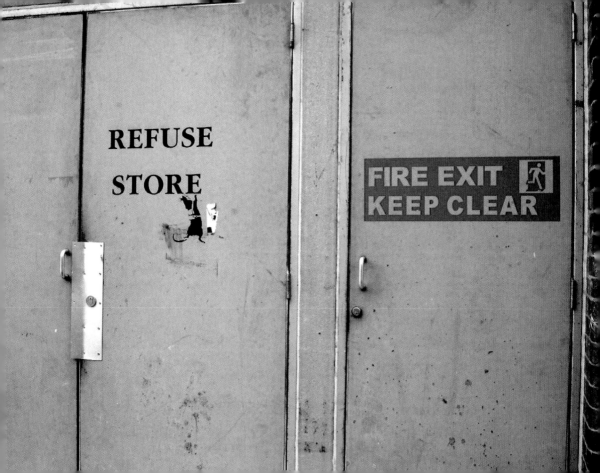

BLT TIP

If you are energetic, you could continue up St. John's Street, and then across Rawstorne to see the Banksy vs Faile pieces on Wakely (A501). Not only another great example of Banksy's 'kid' stencil, which he used at least four times in London around May 2006 (this time he is painting a heart on the wall), but also a great Faile stencil ('Fate').

If you are thirsty, you might like to stop off at Filthy MacNasty's, a well-known pub, at 68 Amwell Street, EC1. It's covered with music memorabilia, including some of favorite son Pete Doherty, when he was with The Libertines, and plays an eclectic mix of music. Lenin reputedly drank here in 1905. He's probably not been back for a while though. www.filthymacnastys.com

PAPA'RAT'ZI
Post Code: EC1R 0DY
Map/GPS reference: TQ 31494 82185

Location
At the south end of Clerkenwell Close, close to Clerkenwell
Green. Strangely tucked away on the side of some flats
where few will see this photographer-cum-rat. Worth
mentioning as the 'Banksy' tag is on backwards. A little
bit of alcohol can obviously make for a fun evening....

Status
Fading, but still there.

Next
Return to Clerkenwell Green, and walk down to
the main road — Clerkenwell Rd (A5201). Turn
right, then walk straight over the crossroads.

BLT TIP: Banksy's 'Justice'
statue was famously unveiled to a
scrum of people on Clerkenwell Green
in 2004. Nothing survives today though,
not even an old pair of frilly knickers
(unless you get lucky after the Turnmills
club chucks out on a Friday night).

PENSIONER THUGS
('Thugs For Life'/'Old Skool')
Post Code: EC1R 5DL
Map/GPS reference: TQ 31299 82030

Location

Clerkenwell Rd (A5201), near Saffron Hill. This has had various incarnations (including the occasional tags of 'Thugs For Life' & 'Old Skool') but may not last long. It is now ominously behind bars awaiting redevelopment of the small car park it is part of. It shows Banksy's pensioner thugs with their B-Boy gear, zimmer frames and bling. The massive, and probably painstaking stencils for this graffiti are shown at the end of the hardback edition of the *Wall & Piece* book.

Status

Still there.

Next

Walk anyway you want to get to the Farringdon Rd (A201), but I would suggest using Back Hill (almost opposite Pensioner Thugs) because a newsagent there (Joys Cards & News, 3 Back Hill, EC1R 5EN) has a great shop shutter done by London Frontline (check out www.londonfrontline.com).

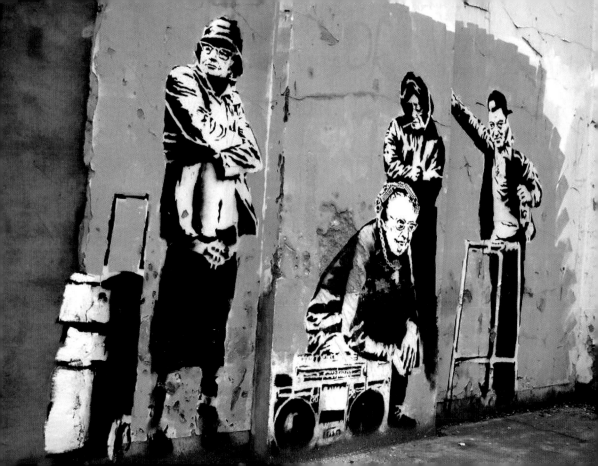

GANGSTA RAT
Post Code: EC1R 4QD
Map/GPS reference: TQ 31193 82422

Location
Roseberry Avenue (A401), very near the junction with
Farringdon Rd (A201). This was on the metal box of
City News (4 Exmouth Market), but, around October
2006 it was reported that the whole box had been
sold off by the shop! A nice shiny new one replaced it.
By November it was already being sold on eBay.

Status
Gone.

Next
Turn around and look over to the other side
of the road to spot the cash machine.

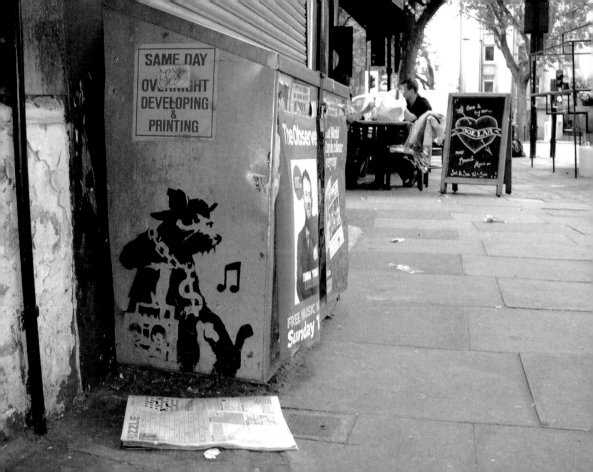

CASH MACHINE & GIRL
Post Code: WC1X 0DW
Map/GPS reference: TQ 31148 82454

Location
Roseberry Avenue (A401), very near the junction with
Farringdon Road (A201). This is quite well known in London,
but strangely I can't find it in any of Banksy's books. It's a
cash machine with a mechanical arm grabbing a girl. What
on earth does this mean? Anyway, a long time ago this site
started as just a small umbrella rat on an old window. When
the window was bricked up, it then had the cash machine put
on it, with Banksy/D*face's 'di-faced' tenners (£10 notes
with Princess Di on them instead of the Queen) spewing out
of it. Later, the arm and girl were added. Wasn't that history
lesson interesting? I could have been a teacher. I would
have loved to try the leather elbow patch and tweed look.

Status
Still there.

Next
Walk up Exmouth market.

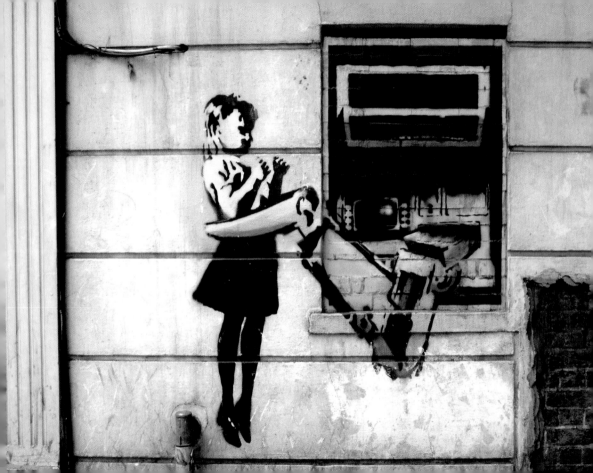

PAPA 'RAT' ZI RAT
Post Code: EC1R 4QL
Map/GPS reference: TQ 31296 82489

Location
On the entrance wall of the 'Movie World' shop,
on Exmouth Market. Another good example
of the mutant photographer-cum-rat.

Status
Peeling, but acceptable. The wall seems to have been
repainted, and they carefully painted around the Banksy ☺

Next
Return to the Farringdon Rd (A201) and continue
passed the enormous Mount Pleasant Post office site.

PLACARD RAT
'Always Fail(e)'
Post Code: EC1R 3AS
Map/GPS reference: TQ 31011 82486

Location
By a bus stop on the Farringdon Road (A201), near the junction with Calthorpe St. This shows another example of Banksy's placard rat. It used to say 'Always Fail', but now reads 'Always Faile', which may or may not be a cheeky pun from the Faile crew! Always Fail' is also a nickname for the Royal Mail, whose massive Mount Pleasant sorting office can be seen in the background of the photo.

Status
Faded but still there.

Next
It's a bit of a walk to either Angel, King's Cross or Farringdon tubes, or a number 53 bus towards either King's Cross or Farringdon.

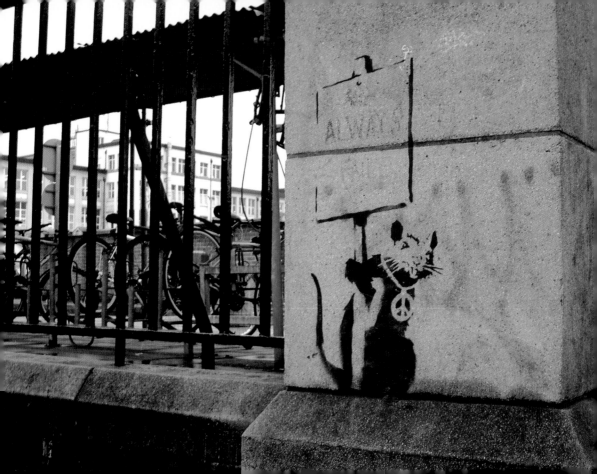

WATERLOO
SOUTH BANK &
VICTORIA ENBANKMENT
A.K.A. THE RIVERSIDE
RAT TOUR

INTRODUCTION

This tour goes around the Lower Marsh/ Waterloo area, then along the South Bank, from the Mortar Rats (opposite the Houses of Parliament) to London Bridge, crossing the river to visit the ones on the north side of the Thames, finishing at Embankment tube station. Unfortunately, most of the featured graffiti on this tour has now gone.

The route goes close to lots of tube stations (London Bridge, Monument, Bank, Cannon St., Blackfriars, Embankment, etc). And also lots of tourist attractions.

Although this is quite a long way, it's all pretty flat and as it doesn't involve any difficult steps, it could be done by someone using a wheelchair or a baby buggy.

You won't need a tube/bus/whatever ticket for this. It's just a lot of walking. When I did it as a tour, it took over two and a half hours. One section of the route can be missed out if you prefer a shorter walk, which is approximately two hours.

START

A convenient starting point is Lambeth North Tube station (Bakerloo Line only). This station is pretty quiet, but is also within walking distance from Waterloo as well, which offers more tube interchanges (Jubilee, Waterloo and Northern lines) and national rail services.

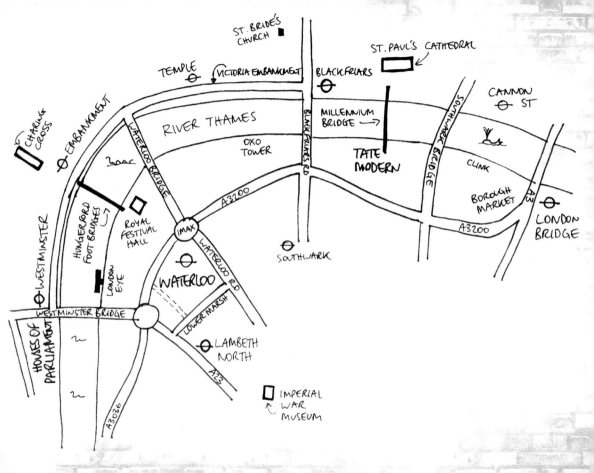

WRITING RAT
Post Code: SE1 7AB
Map/GPS reference: TQ 31209 79751

Location
Corner of Lower Marsh and Baylis Road.

Directions
From Lambeth North Station, turn right out of the station
and walk down Baylis Rd. From Waterloo Station, come
out the Waterloo Rd exit. Turn right and walk down
Waterloo (A301), to Baylis Rd and Lower Marsh.

It seems like Banksy blitzed the Lower Marsh area at some
point. This is a rat piece I've not seen elsewhere, with a
marker pen in its hand. This was on a telecoms metal box
(always a favorite Banksy target!) but has now been buffed.

Status
Buffed.

Next
Continue up Lower Marsh.

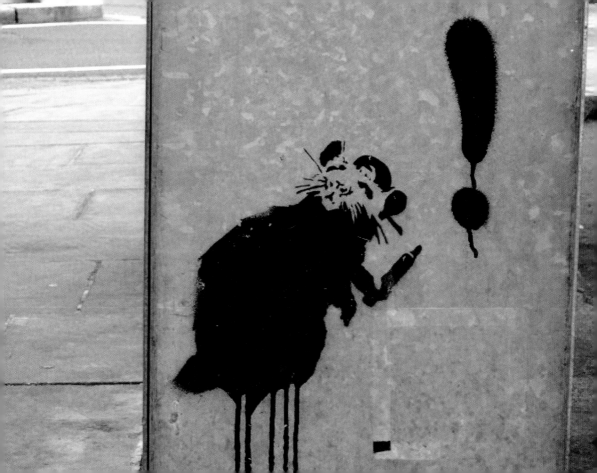

GHETTO BLASTER RAT
Post Code: SE1 7AB
Map/GPS reference: TQ 31161 79762

Location
On the metal box outside 'Supreme General Stores' on Lower Marsh. On one of Banksy's favorite mediums, the metal boxes outside newsagent shops. Often partly obscured by posters.

Status
The entire metal box has since vanished and has been replaced by a nice new one. A man in the shop told me it had been stolen (in February 2007, I think).

Next
Continue up Lower Marsh, on the same side of the street.

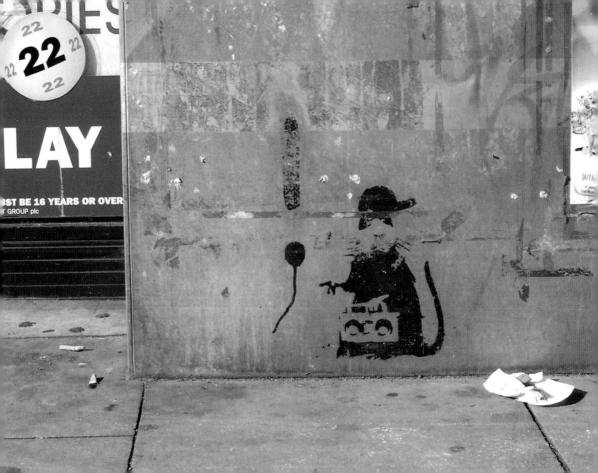

DESIGNATED PICNIC AREA
Post Code: SE1 7AD
Map/GPS reference: TQ 31070 79688

Location
On the side of a skanky alley about half way along Lower
Marsh, next to Crockatt & Powell Booksellers. Usually the
arrow will invariably be pointing to some litter or rotting veg!
Lower Marsh is still a very active and historic market area.

Status
Still slightly visible (see inset photo) but was pretty much
buffed by the local Council even though the lovely bookshop
owners didn't want it removed and had told them that!

Next
Continue up Lower Marsh, on the same side of the street.

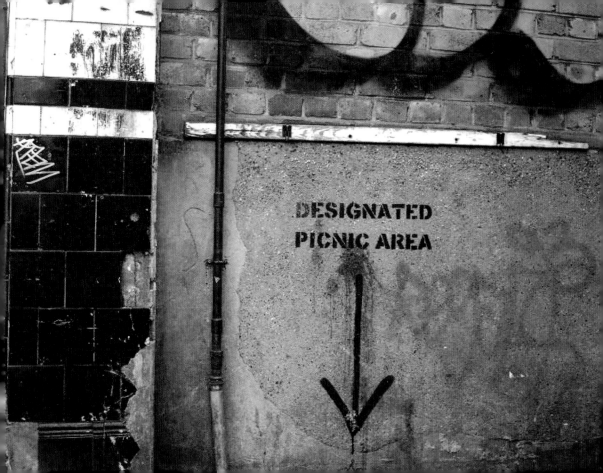

HELP ME RAT
Post Code: SE1 7AE
Map/GPS reference: TQ 31017 79637

Location
On the metal box outside a newsagent on Lower Marsh
(opposite Ryman's). This is a rat piece I've not seen
elsewhere, featuring a rat scrawling 'help me' on a
newsagent's metal box, always a favorite Banksy target!

Status
In early 2007, the 'help me' phrase was scrawled over (see
inset photo.) By mid-March the whole box had gone and the
shop always seemed to be closed. Later, I was contacted
by the new 'owner' who said that he had bought the box
from the newsagent before the shop had closed down.

Next
Turn around and return just a few meters down
Lower Marsh, before taking the pedestrian walkway
down to the underneath of Waterloo Station.

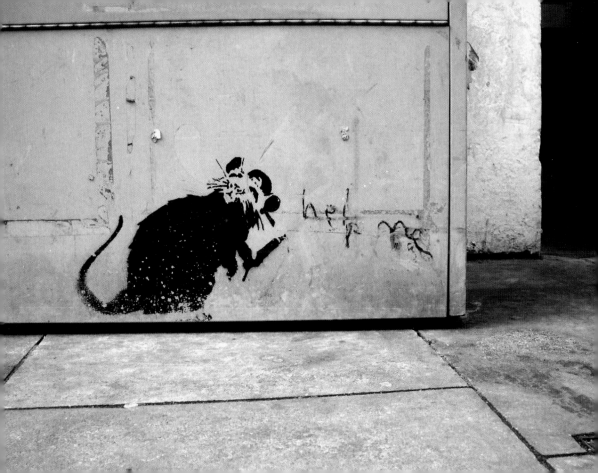

MONKEY DETONATOR
Post Code: SE1 7AE
Map/GPS reference: TQ 30997 79717

Location
In the tunnel underneath Waterloo Station, at Leake Street.
When I took a group on a tour of graffiti in Shoreditch, one
person commented "I've never been in so many skanky alleys
in my life." This Waterloo underpass is far more piss-stained,
like a monkey who detonated a bunch of bananas...

Status
This was painted over in October 2006 (see inset photo).
Once the press heard about it many months later (and had
printed the seemingly obligatory half-true story), there
were a few transport bosses left with egg on their faces.

Next
Continue along the underpass, probably
holding your nose by this point.

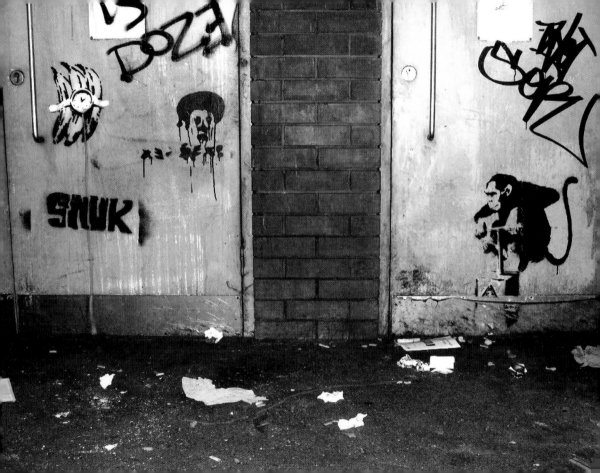

SNORTING COPPER
Post Code: SE1 7NN
Map/GPS reference: TQ 30890 79791

Location
Just out of the tunnel underneath Waterloo Station (Leake Street). Banksy's infamous Snorting Copper, now made rarer by being the only surviving example since the Shoreditch (Location S19) one was buffed. Note the Space Invader above it.

Status
Still there, but it is seriously fading, (especially the face.) [The Space Invader above is still perfect].

Next
Continue to the main road (York Rd) and at the roundabout, head for Westminster Bridge.

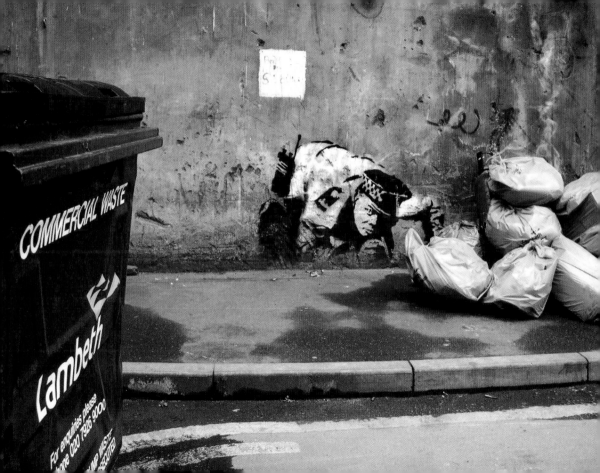

MORTAR RATS
Post Code: SE1 7NN
Map/GPS reference: TQ 30890 79791

Location
Two separate (but similar) examples, on the riverside granite blocks of the pedestrian walk of the South Bank. One is close to Westminster Bridge. The other is several hundred meters further up, towards Lambeth Bridge. The Houses of Parliament and Big Ben can be spotted looming in the background, it's assumed target. Banksy's tag is just visible in the corner of each. One has had some diving figures added to it; I doubt these are by Banksy as they seem to spoil the composition.

Status
Both were buffed in mid-2007, although the small tag can still be spotted on one.

Next
Return to Westminster Bridge and walk under it (towards the London Eye).

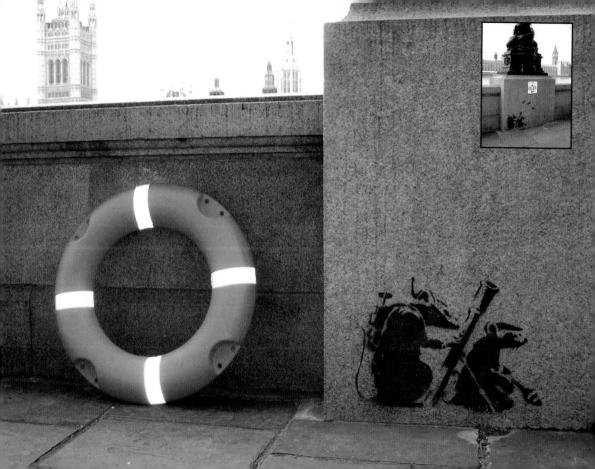

THIS IS NOT A PHOTO OPPORTUNITY
Post Code: SE1 7JA
Map/GPS reference: TQ 30594 79812

Location
On the riverside granite blocks of the pedestrian walk of
the South Bank, close to the London Eye (by the largest Dali
Statue). Possibly Banksy's most photographed stencil, as
many people deliberately or accidentally get their photos
taken here (it overlooks both Houses of Parliament).

Status
Buffed in mid February 2007.

Next
Continue along the South Bank.

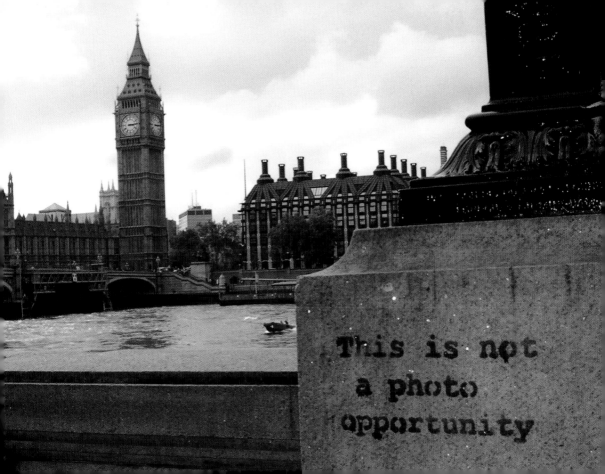

BLT TIP

This area (R7 & R8) is a good area to spot the white line on the walkway.

This was a white line that stretched for a long way. It seems to start around the London Eye, and run along the south bank, over Lambeth road and around the houses to a bridge in Whitgift Street.

I think a snorting copper was at that end, but there's nothing to be seen now.

SAWING RAT
Post Code: SE1 7NN
Map/GPS reference: TQ 30890 79791

Location
On the riverside granite blocks of the pedestrian
walk of the South Bank, just before the Hungerford
Footbridges, a rare sawing rat, complete with
cigarette and beret. The circle on the pavement that
accompanied these sawing rats is long gone, though.

Status
Buffed in mid 2007.

Next
Continue along the South Bank.

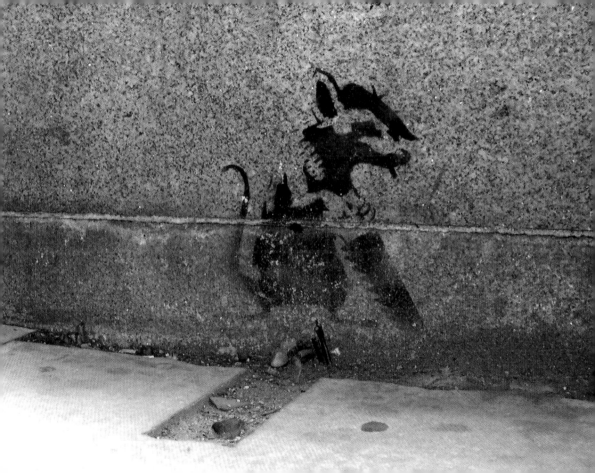

GHETTO BLASTER RAT
Post Code: SE1 8XZ
Map/GPS reference: TQ 30764 80331

Location
On the riverside granite blocks of the South Bank's
Pedestrian walkway; on the entrance to Festival
Pier opposite the Queen Elizabeth Hall.

Status
Still there, but has been scrawled over with
some bubble graffiti. Very faded.

Next
Continue along the South Bank.

BLT TIP: 'BORING' was
infamously sprayed by Banksy, using a
modified fire extinguisher, in massive
red letters on the Waterloo Bridge
side of the National Theatre.

TINY SMILEY COPPER
Post Code: SE1 8TL
Map/GPS reference: TQ 30895 80427

Location
On the riverside granite blocks of the South Bank's
pedestrian walk, just after Waterloo Bridge/Hungerford
Footbridges. This may or may not be a real Banksy.
It is so small (and not seen elsewhere) and not great
quality (not helped by the rough granite surface).
I did see it before it was mainly buffed, but I've
lost my photo of it in a better condition! D'oh.

Status
Almost gone.

Next
Continue along the South Bank to the Tate Modern.

BLT TIP: There were two Girl With
Balloon stencils along the South bank. Both
have gone, but are still slightly visible. One
was on the East side of Waterloo Bridge
(by the National Theatre). The other was
on the East side of Blackfriars Bridge.
There were also a few 'Buried Treasures'
but they have also virtually gone.

THIS IS NOT A PHOTO OPPORTUNITY
Post Code: SE1 9TG
Map/GPS reference: TQ 31973 80541

Location

On a rusting old rubbish bin, on the pedestrian walk of the South Bank, right outside the Tate Modern. Note the Banksy 'homage' also in the photo. It's of a tiny pissing soldier (a classic older Banksy piece,) marked 'spank me', using the typeface ('stop') that Banksy uses for his tag.

Status

Gone. The whole bin was freshly painted in mid 2007.

Next

Continue along the South Bank, past the Clink (where there used to be Banksy stuff) & Stoney Street, and into Park St.

BLT TIP: For a shorter tour miss out R13 & 14 by crossing over the river on the Millennium Foot bridge (the 'wobbly' bridge) and continuing to R15.

THIS IS NOT A PHOTO OPPORTUNITY
Post Code: SE1 9TG
Map/GPS reference: TQ 31973 80541

Location
On a lovely old building on Park Street, behind Borough
Market. This building was used as the hideaway in
the film *Lock Stock and Two Smoking Barrels*.

Status
A black stencilled graffiti has also been added
right next to the Banksy (see photo)

Next
Go back to Borough Market, join Borough High St. (A3)
and head over London Bridge. Go down to the riverside
walk on the north side of the river. Walk westwards.

BLT TIP: As you walk past the
'London Bridge Tandoori Restaurant'
on the south side of London Bridge, you
might recognise the advertising hoarding
where Banksy scrawled 'The Joy of Not
Being Sold Anything'. As show on a video
on Banksy's site, and in the 'Pictures
of Walls' book. Post Code – SE1 9QG/
Map/GPS reference – TQ 32701 80267

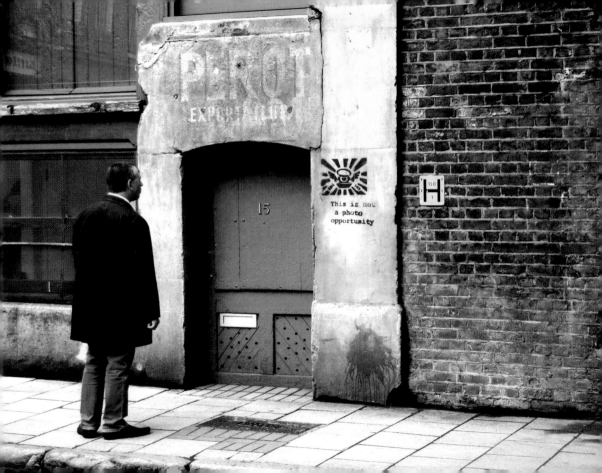

PLACARD RAT – YOU LOSE
Post Code: EC4R 3UE
Map/GPS reference: TQ 32586 80661

Location
At the riverside end of All Hallow's Lane, underneath
Cannon Street station. This really sticks in my mind because
when I first visited it, I found a guy next to it, living in
a cardboard box, with little except a radio and blanket.
It felt really meaningless to take the photos, and also, it
could be demeaning to to the man. I talked with him for
a long time, and asked 'permission' to take a photo of
the wall (not getting him in the photo). The irony of the
placard 'message' dug home. This is just one reason I
support *The Big Issue*, I try to talk to people I meet rather
than just pass them by, and I try to help them a little.

Status
Still there, but the whole tunnel is being redeveloped.

Next
Continue along the riverside to Blackfriars. Unfortunately
there are a few bits on this side of the river where it isn't a
riverside path as such, and you have to take detours inland.

BLT TIP: It is difficult to explain how
to get to R15. A map and the use of the
subways at Blackfriars station will help.
You can obviously miss it out if you prefer.

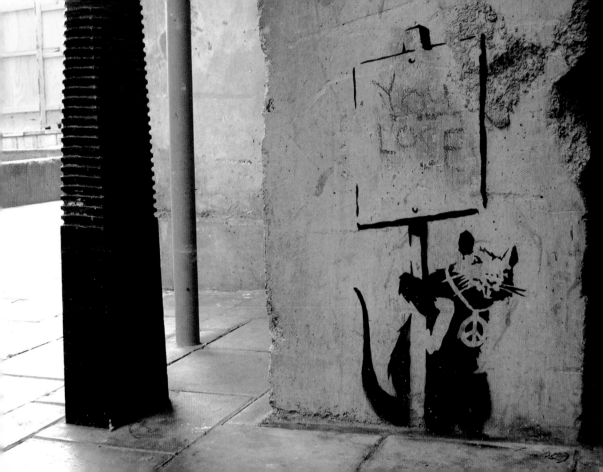

POISON RAT
Post Code: EC4Y 8AU
Map/GPS reference: TQ 31573 81134

Location
On the steps of a little passageway to St. Bride's Church.
Just off of Bride Lane. Although this is not the greatest
Poison rat left in London, it is the one with the best setting,
as it not only has Saint Bride's Church (the famous 'Fleet
Street church') in the background, but also cleverly uses
the steps as if the rat is pouring green waste down them.

Status
Faded but still there.

Next
Return to the riverside as best you can.

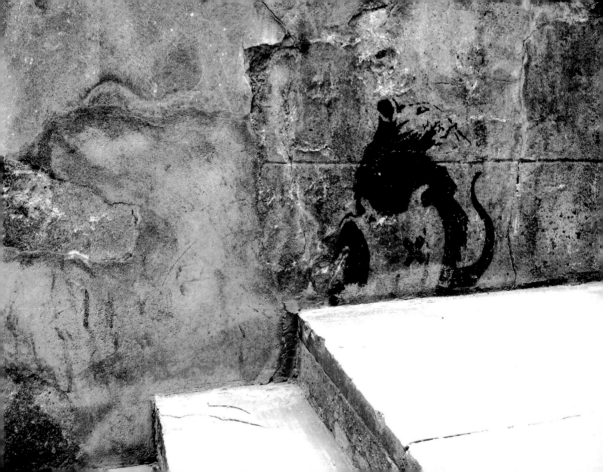

PHOTOGRAPHER RAT
Post Code: EC4Y 0HJ
Map/GPS reference: TQ 31320 80802

Location
On a metal utilities box on the Victoria Embankment
(A3211), just after Blackfriars, near the boat HMS
President. That's me. A photographer rat. Again, this
Banksy stencil seems to get respect. Each time I see it, the
stencil has a different variety of stickers surrounding it.

Status
Still there, but a bit defaced.

Next
Continue along the riverside (Victoria Embankment).

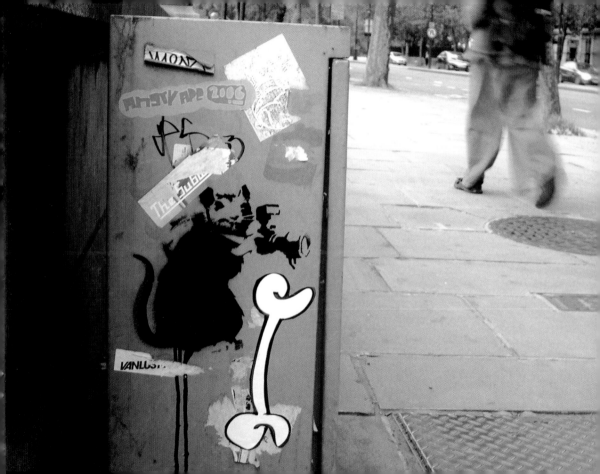

PLACARD RAT QUESTION MARK
Post Code: WC2R 2PP
Map/GPS reference: TQ 31043 80786

Location
On the granite section of the riverside wall, near a memorial
on the Victoria Embankment (A3211). Near the boat HQS
Wellington. Opposite Temple tube station. An excellent
placard rat, with a big question mark on the placard.

Status
Still visible, but very faded now. A bad buff job, I presume.

Next
Continue along the riverside (Victoria Embankment).

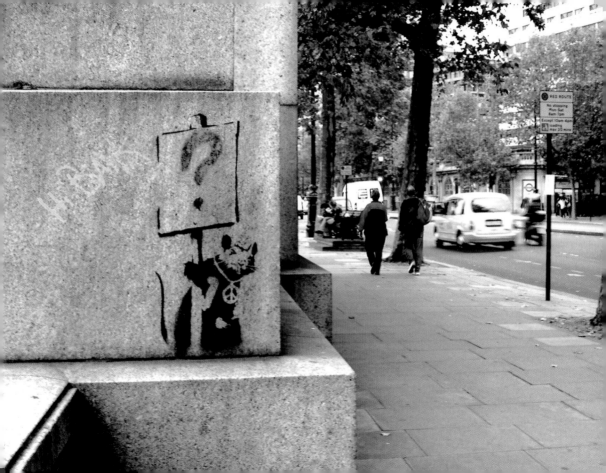

PHOTOGRAPHER RAT
Post Code: EC4Y 0HJ
Map/GPS reference: TQ 31320 80802

Location
Above a green utilities box under Waterloo Bridge, on the corner of Savoy Street. This was a very clean rat until rude, and frankly rather confused graffiti was added close to it. Something about polos and blow jobs. Note the 'Cept' tag on the utilities box – a rare sight this far south!

Status
Buffed in mid-2007.

Next
Continue along the riverside (Victoria Embankment).

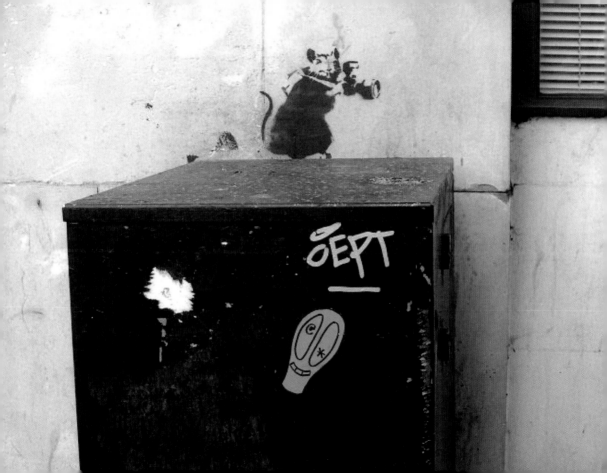

PLACARD RAT
GO BACK TO BED
Post Code: WC2N 6NS
Map/GPS reference: TQ 30438 80323

Location
On the massive concrete struts of the Hungerford footbridge
(east side). Opposite the Embankment tube station, on
the Victoria Embankment (A3211). Another 'Go Back To
Bed' rat. Perfectly placed to catch commuters and early
morning joggers, both of whom should know better.

Status
Buffed in mid-2006.

Next
From this end point it is easy to get anywhere. Embankment
tube is right in front of you, and it's a really easy walk
to Charing Cross, Trafalgar Square or Waterloo.

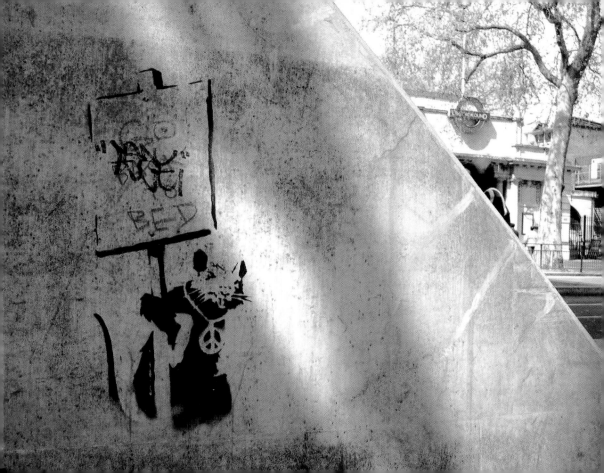

THANKS AND ACKNOWLEDGEMENTS

Obviously the real credit must go to all the writers who do their work on the street. Please support them. Links to their various websites are on the next pages.

The first, and main thanks has to be for Stef, who asked me, in one of those Friday afternoon moments, if I had ever thought of making my tours and photos into anything more, such as a book (I had – great minds thinks alike eh? – but the book mapped out in my head was on Eine, not Banksy). He also pushed me all the way through the process, did all of the painstaking graphic design and put up with my perfectionism.

The second thanks has to be for Sam, who handled all the print brokerage, helped me on the streets (no, he isn't actually my pimp..... although it may feel like it some times,) generally encouraged me, and was always around for a chat and a wander.

Respect to Steve at Art of the State, and Tristan Manco, Godfathers of graffiti info.

And as mentioned at the start of the book, thanks to all the people who responded to my leading questions and annoyance of where to find some of this graffiti.

Although this book is in no way sanctioned by Pictures On Walls or The Big Issue, I greatly respect them both and give thanks to their work. Particular thanks to lovely Steph who used to work @ POW.

CREDITS

All photographs (bar two – see below) and text are by Martin Bull. Hand printed, limited editions of his black & white photos of graffiti are available via www.shellshockphotos.co.uk

Many thanks to Dave and Juliette for their photograph of the Shoreditch tour in September 2006 (shown just before location S18).

Many thanks to Sam for his photograph of the tour of Waterloo/South Bank in August 2006 (shown at the introduction to that section).

Many, many thanks for all the graphic design by Stef at Hoodacious – www.hoodacious.co.uk